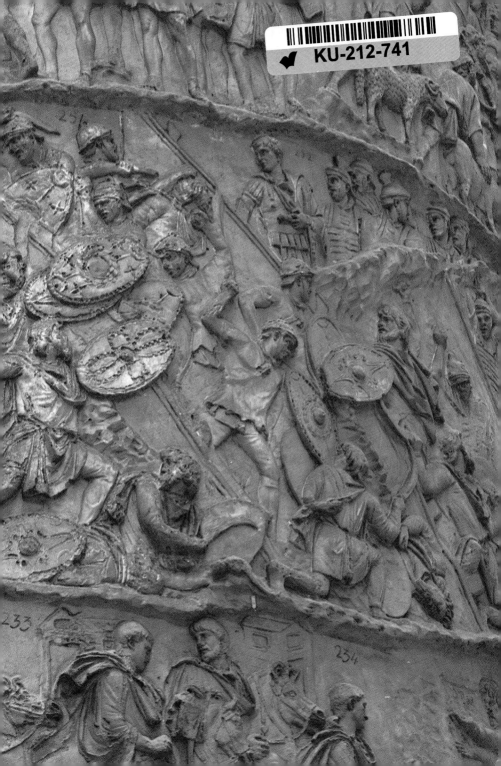

ABBEVILLE LIBRARY OF ART

ANCIENT ROME

꧁꧂

Introduction by Malcolm A.R. Colledge

Commentaries by Michael Davison

Abbeville Press · Publishers · New York

FRONT COVER
NERO AS ALEXANDER
Commentary on page 58

FRONTISPIECE AND TITLE PAGE
TRAJAN'S COLUMN
Commentary on page 112

PHOTO CREDITS
Pages 17, 23, 61, and 88: Ronald Sheridan
All other photographs: Michael Holford Library

Library of Congress Catalog Card Number 79-57555
ISBN 0-89659-124-7

CONTENTS

INTRODUCTION

THE PATH that led the Romans to domination of the Mediterranean world was a long and thorny one. Great movements of population between three and four thousand years ago brought speakers of the Latin language to Latium in central Italy; and there, on the future site of Rome, villagers were living before the Bronze Age ended. But with the coming of ironworking, Rome began to stir. In the eighth century B.C., the villages scattered around the Roman hilltops developed a sense of community and a common king; centuries later, when they had forgotten the true sequence of events, the Romans wove their surviving memories of this into the legend of their founder and first monarch, Romulus. A senate of elders was formed, together with an assembly of male members of the Roman tribes. This development, however, was rudely interrupted by Etruscan invaders from north Italy, who imposed their own kings throughout the sixth century B.C. They transformed the still rustic villages into an organized, unified township with streets, sanctuaries, and a meeting place, or forum—all of Etruscan design, developed from Greek models. About 509 B.C. the Romans rebelled and

ejected their foreign overlords; but the trappings of Etruscan kingship and the forms and practices of Etruscan architects and artists were to mark Roman culture for centuries. Loathing now the very notion of kingship, the Romans instituted a Republican system of government headed by two consuls with equal power, who, like the lesser magistrates, were elected annually at assemblies of the people. The Senate survived as a powerful deliberative body, and in emergencies a special supreme magistrate, the dictator, could be appointed for a maximum term of six months. Despite innumerable vicissitudes, this governmental system lasted nearly half a millenium. Under senatorial leadership Rome fought off fierce attacks by surrounding Italian peoples, gradually transforming her army from an ill-led body of peasants into an efficient state militia of legions six thousand strong under experienced senatorial commanders, each legion divided into sixty "centuries" under tough centurions. Such was the army that conquered Italy in the fourth century B.C.; Sicily, Sardinia, and Hannibal and the Carthaginians in the third; Spain, North Africa, and Greece in the second; and France, Asia Minor, Syria, and Egypt in the first. Of these diverse and often rich areas, now organized into tax-paying provinces, Greece, in her sophisticated Hellenistic phase, was to exert the greatest cultural influence on the conquerors. But when senatorial generals such as Julius Caesar began to use their portions of the army against rival senators rather than against state enemies, the Republic collapsed and civil war ensued.

From this chaos Caesar's great-nephew Octavian, soon to be renamed Augustus, emerged in 31 B.C. as victor and created

a new world order. Henceforth one man, the emperor, was to rule the empire; under him the Senate continued to deliberate, and the magistrates and generals to execute orders. This system, the "principate," was to prove immensely enduring. Emperors acquired new territories: Britain (A.D. 43), Romania, and Jordan (A.D. 106). With their vast funds, they commissioned lavish buildings, statues, friezes, coins, paintings, and mosaics to spread their propaganda; their subjects, enjoying the prosperity brought by the Roman peace, followed suit, developing the traditions of their areas. The principate survived constant pressure from foreign tribes and kingdoms, an economic and military crisis in the third century A.D., a transformation under Constantine the Great into a Christian state, and the splitting of the empire into two halves, with a new capital at Constantinople, in the fourth century. When the western half, including Europe and North Africa, succumbed in the fifth century A.D. to invading Germanic tribes—Goths, Vandals, and others—much of the Roman administration and art was destroyed; but the eastern portion survived as the Byzantine Empire until Constantinople itself fell to the Turks in 1453.

The Romans, as they themselves recognized, were in general more talented as administrators than as artists. But they were receptive to outside ideas, and as patrons they could guide artists into channels previously unimagined. Throughout Rome's ancient history, the metropolis absorbed ideas from two traditions in particular: the Italian, especially from the areas of Etruria and central Italy; and the Greek, most notably from the second century B.C. Rome's more distant

provinces often possessed tenacious traditions of their own: Celtic in Europe and Britain, Phoenician in North Africa, Pharaonic in Egypt, and Babylonian and Iranian in the near east. Some of these provinces—Egypt, for example—contributed to art in Rome, but more often their own styles were Romanized. Differences in taste between individual patrons, between one area or social group and another, between the wealthy and those of lesser means, and differences in craftsmanship between the workshops they patronized all added to the lively variety of artistic output under the Roman aegis.

Rome's first acquaintance with monumental architecture came with the Etruscan domination of the sixth century B.C. Etruscan temples arose, vaguely Greek in inspiration but standing on high bases with frontal steps, deep columned porches, and wide (sometimes triple) halls for divine statues in mud-brick or stone and timber. Such Etruscan forms, and some techniques, remained influential even under the emperors. The Roman conquest of Italy, including the Greek colonial towns of southern Italy and Sicily, brought Romans into contact with Greek stone architecture, with its finely cut blocks, columns, stone lintels, and beams, and decoration in the Doric, Ionic, and Corinthian orders. But the ingredient that enabled Roman architects to revolutionize ancient building came from nearer to home, especially from the Naples area: volcanic dust, which could be combined with other materials to form concrete. From the second century B.C., Roman builders experimented ever more daringly with this versatile material, clothing the core in a decorative skin of small stones or bricks. Its early uses were comparatively mun-

dane—in administrative halls, record offices, temple foundations, and the like; but in the hands of the emperors it became a massive vehicle for display, as Roman builders mastered its engineering problems. Great vaulted and domed imperial palaces with ingeniously shaped courts and rooms arose at the direction of Nero and Domitian; Trajan laid out an enormous new forum; his successor Hadrian erected a villa, breathtaking in its size and novelty, at Tivoli outside of Rome. Many emperors built huge public baths, and Constantine completed an enormous administrative structure, a basilica. But however daring these ideas, such was the prestige carried by Greek tradition that Roman builders always felt obliged to provide their creations with a decorative veneer drawn from the Greek architectural repertoire, whether in stone, stucco, or paint. Many Roman forms, such as temples, town walls and gates, theaters, and houses, were inspired by Etruscan and Greek traditions, though most of the new structures were on the grander scale permitted by concrete—triumphal arches, baths, amphitheaters, towering apartment blocks, great new forums, or the immense palace complexes. Yet despite its success in and around Rome, concrete remained essentially a phenomenon of central Italy. Elsewhere around the Mediterranean, and in Europe, there was a complex interaction between earlier tradition, especially that of Greek cut-stone work, and new Roman forms. In this way other cultures continued to evolve, producing delightful and imaginative buildings.

The Etruscan kings of the sixth century B.C. doubtless familiarized the inhabitants of Rome with their unusual ver-

sion of Greek art, particularly their statuary and architectural relief—two forms that remained Roman favorites after the Etruscans' departure. But when the Romans turned Greece into Roman provinces during the second century B.C., they were seduced by the glory of contemporary Hellenistic art, with its subtle and dramatic idealized naturalism and its incomparable expertise in a wide variety of media. The conquerors imported Greek art and artists wholesale into Rome, where they predominated among the capital's artists for centuries. Greek art forms were enthusiastically adopted: silver coinage, statuary of deities and mortals, realistic portraiture in marble, bronze, and paint, architectural relief, wall-painting, floor mosaics with geometric and figured designs, gold and silver utensils, and exquisite jewelry. These were profoundly influential in molding late republican and imperial Roman taste. But despite this the Romans, as patrons and sometimes as artists too, handled Greek tradition in a creative way. Their practical instincts led them to transform Greek art, wherever feasible, into a vehicle for documenting their own achievements in ways the Greeks never conceived of; nor was their own Italian heritage forgotten. Thus coinage in gold, silver, and bronze became a leading propaganda medium, with the ruler's profile on the obverse and a relevant deity or scene in miniature on the reverse. Imperial and private portraiture in sculpture and painting blossomed, producing a continual stream of masterpieces. For the tombstones of the middle class, funerary relief busts became popular.

Wall-painting in the first century B.C. was a rich medium in which colorful scenes from mythology, daily life, and nature

were set into an architectural framework; and further decoration was often added to buildings in the form of exquisite painted frescoes. Mosaics with geometric and figured compositions proliferated as a covering for floors, and gradually for walls and vaults as well. Utensils and jewelry in silver and gold became ever more luxurious. But the greatest Roman artistic innovation was the creation of a splendid series of state propaganda reliefs attached to prominent public buildings: altars, forums, triumphal arches, and such spiral columns as those of Trajan and Marcus Aurelius. In these carvings, the Romans' documentary tendencies were merged with Greek artistic expression for the glorification of the Empire and its rulers; they represent Roman art at its most characteristic and impressive.

—Malcolm A.R. Colledge

Romulus and Remus

THE RECORDED HISTORY OF ROME starts with the expulsion of the last Etruscan kings and the foundation of a republic in 509 B.C., but Romans liked to trace the origin of their city back to a much earlier date. They invented a history for the intervening centuries in which local tradition and classical myth became inextricably interwoven. The founding date of the city was traditionally set at 753 B.C., and attributed to the legendary Romulus, from whom its name was believed to be derived. Romulus and his twin brother Remus were said to have been suckled by a she-wolf, which thus came to be seen as the symbol of Rome itself. This four-foot-long bronze figure of the sinewy, watchful she-wolf dates back to about 500 B.C.; the figures of the twins were added in Renaissance times.

For the origins of their race, the Romans looked back to an even remoter past that included the figures of the Trojan prince Aeneas, who escaped from the sack of Troy and sailed to Italy. Romulus and Remus, the grandsons of Aeneas, were forcibly begotten by the wargod Mars upon a human princess, Rhea Silvia, who as a Vestal Virgin had taken a vow of chastity. To punish Rhea Silvia for breaking her vow, her uncle Amulius abandoned the boys by the Tiber to die; but they were found and suckled by the she-wolf, an animal sacred to Mars, and brought up as herdsmen by a local shepherd. Later the brothers decided to found a city by the Tiber, but quarreled over the choice of site. Romulus killed Remus and then traced out with his plow the boundaries of the city of Rome on the Palatine Hill. He became the first of the city's legendary kings.

500 B.C. Capitoline Museum, Rome

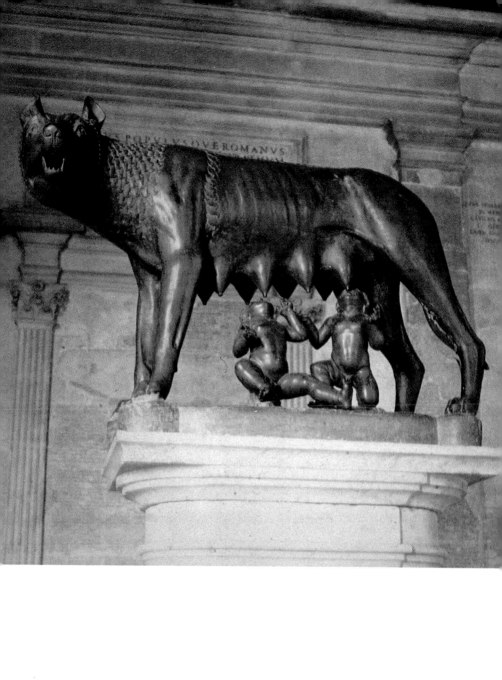

Consul of the Republic

THE FIRM PURPOSE and high ideals that characterized the fathers of republican Rome are powerfully evoked in this marble statue of an unnamed consul. Swathed in the voluminous folds of his toga and clutching a scroll, the consul stands proudly erect, close-cropped and tight-lipped, his rugged features blazing from the cold marble.

The Romans expelled the last of their kings in 509 B.C., and for the next five hundred years Rome was governed under a carefully planned republican constitution. The former authority of the king was transferred to two consuls, elected by the people for a period of one year only. Their election was subject to the approval of the Senate, a council formed of the wealthy families of Rome. Each consul could veto the actions of the other and as time went on, their powers were further restrained by the growing influence of tribunes chosen by the ordinary citizens of Rome; but they always had sections of the Roman army under their control, and determined consuls such as Marius, Sulla, and Pompey came to wield enormous personal power. Feuding between rival consuls, and the ambition of senator-generals challenging the power of both, contributed to the breakdown of the republic and finally led to the concentration of power in the single person of an emperor.

The large number of lifelike statues in stone and bronze that survive from Roman times form a vivid portrait gallery of statesmen, soldiers, emperors, and ordinary people. The likenesses are uncompromisingly realistic, often depicting their subjects in old age, bald-headed and wrinkled. The sculptors were often Greeks working for Roman patrons, and they drew on two major sources in developing their art. One was the realistic portrait sculpture of the Hellenistic world of the second century B.C. that the Romans inherited; the other was the older Roman tradition of the *imagines*—masks of distinguished ancestors made in clay, wood, or wax, which noble families kept as household treasures and carried in funeral processions.

First century B.C. or first century A.D. British Museum, London

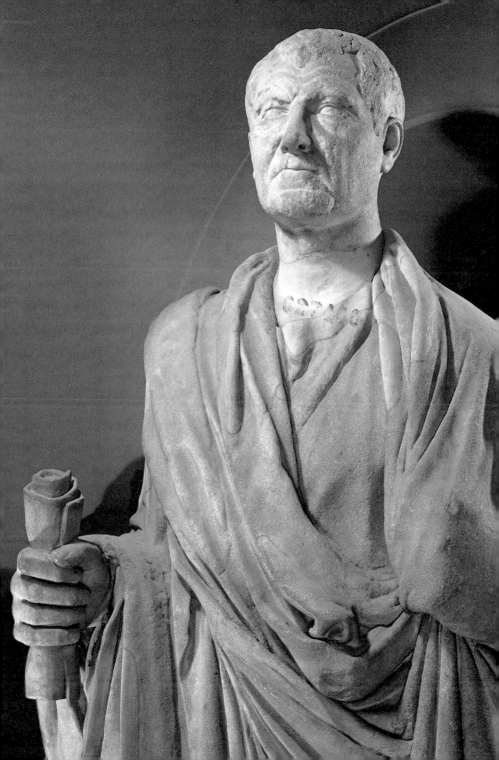

Julius Caesar Coin

THE FIRST ROMAN COINS were cast in about 290 B.C., but more than two hundred years were to pass before they bore the likeness of a living ruler. The earliest coins were simple bronze ingots bearing the image of an ox; oxen were an even earlier form of currency, and the Latin word for money, *pecunia*, is derived from *pecus*, "cattle." Later republican coins in bronze, silver, and gold bore representations of gods and goddesses and of episodes in the legendary history of Rome. They also showed images of ancestors of the moneyers—the special magistrates authorized to issue coinage. But the stern morality of the early Romans prohibited them from glorifying living persons by putting their likenesses on coins.

The ruler who made the change was the dictator whose effect on Rome was revolutionary in so many ways: Julius Caesar. His image appears here on a *denarius*, the Romans' principal silver coin; it shows him wearing the *corona aurea*, a triumphant general's golden wreath of laurel leaves. The coin is inscribed: *Caesar dict[ator] [in] perpetuo*, "dictator for life."

The powers of dictator had traditionally been conferred for a maximum of six months to give one man authority in time of crisis; Julius Caesar was the first ruler to be given these powers in perpetuity. His authority was based on the loyalty of his army, which he had led in eight years of triumphant campaigning in Gaul. With his soldiers behind him, Caesar marched on Rome, expelled his rival consul Pompey, and assumed dictatorial powers. His dictatorship gave Rome stability, but republican distrust of one-man rule remained deep-rooted, and he was assassinated in 44 B.C. In the civil war that followed, currency came to be used blatantly by rival politicians as a means of self-advertisement.

44 B.C. British Museum, London

20

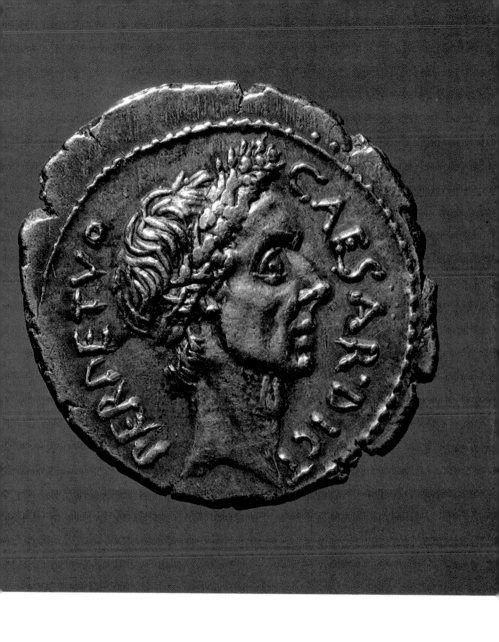

Basilica at Pompeii

A KEY BUILDING in the layout of the typical Roman forum was the basilica, a roofed or partly roofed hall where businessmen could conduct their dealings sheltered from the rain, wind, and sun. The structure usually contained a court of law as well, where disputes were resolved by a presiding magistrate. The basilica takes its name from the Greek word *basilika*, meaning "royal house."

The first basilicas were built in Italy in the second century B.C. The fluted columns immediately bring to mind the pillars of a Greek hall or temple, though these columns are made not of marble but of kiln-dried bricks covered with stucco. Four steps lead up to an open porch, beyond which lay a central nave nearly two hundred feet long, enclosed by twenty-eight great Ionic columns. A narrower aisle, or ambulatory, ran all the way around the central hall. Spaced at intervals along one of the side walls of this ambulatory can be seen Ionic half-columns used in a purely decorative fashion, unlike the freestanding columns which once supported the roof. At the far end of the hall, opposite the entrance, is the tribunal, where the magistrate sat to deliver his judgments; this was a two-story building raised on a podium and fronted by columns, and entered by steps on either side.

Many Roman basilicas were later turned into Christian churches. Their basic pattern of a central nave flanked by side aisles was a lasting influence on church architecture.

c. 120 B.C.

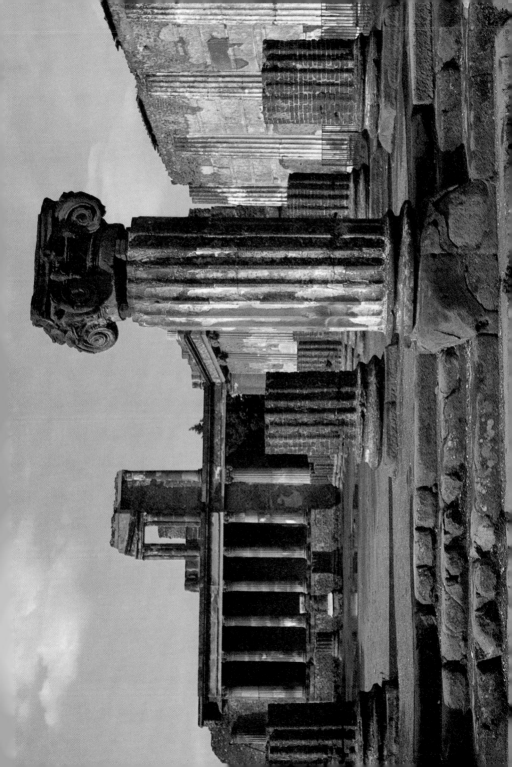

Head of a Woman

THE FAMOUS ROMAN ART of portrait sculpture is well represented by this finely modeled head, carved in the later days of the Republic. The technique of portrait sculpture was largely derived from the Hellenistic world that the Romans conquered; and in many cases, the marble used for the sculptures was imported from the same quarries, located near Athens and on the island of Paros, that yielded the stone for the Parthenon and the Venus de Milo.

The fine modeling on this head was achieved mainly by the use of chisels of varying thickness. The edge of a flat chisel was used to engrave details of the hair, nose, and mouth; on the ear, the nostrils, and the lips there are signs as well of the iron-tipped bow drill, increasingly used by later sculptors to give added depth to the hair and the drapery of their subjects.

The statue's lifelike features suggest that it was modeled on a living person. There is a strong possibility that she may have been Cleopatra, the beautiful and fateful queen of Egypt whose entanglements with Julius Caesar and Mark Antony played a large role in the civil wars that brought the Roman Republic to a close. The identification is suggested by the prominent nose and firm chin, seen also in portraits of Cleopatra that appear on coins of her realm. If the sculpture does represent the young queen, it may well have been carved to celebrate the personal triumph she enjoyed in Rome during the two years she spent there as the consort of Julius Caesar, from 46 B.C. until his assassination.

First century B.C. British Museum, London

24

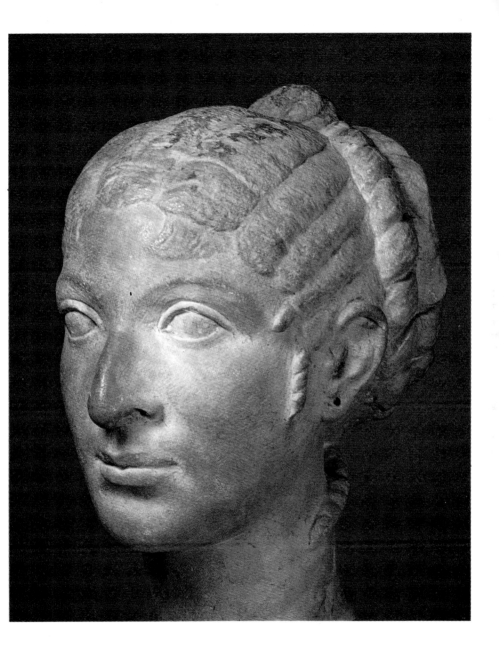

Garden Room of Livia

SOME OF THE FINEST ROMAN PAINTINGS are the landscapes commissioned by wealthy patrons to decorate the walls of their country villas. One of the masterpieces of this genre is the long mural, ten feet high, which ran around the four walls of the Villa of Livia, at Prima Porta on the outskirts of Rome, giving the impression of a huge picture window looking out in all directions onto a rich garden. In the section shown here, a grassy path is enclosed by a trellis fence and a low stone wall; the line of the wall is relieved by a niche enclosing a tree. Behind the wall grows a profusion of shrubs bright with flowers and trees laden with fruit, probably pomegranates. Beyond, a wilderness of taller trees, with birds perching in their branches, stretches back toward the hills on the skyline in a misty sea of blues and greens. The individual flowers and trees are realistically painted, but the artist has idealized the scene by allowing flowers to bloom and fruits to ripen at the same time.

The villa was the country home of Livia, third wife of the emperor Augustus and mother of Tiberius, his successor. The time of Augustus was notable for its romantic dedication to the cult of nature, expressed not only in the paintings of artists such as the one commissioned by Livia to adorn her villa, but also in the poetry of Virgil, particularly his *Georgics* and *Eclogues*.

Late first century B.C. Museo Nazionale Romano delle Terme, Rome

26

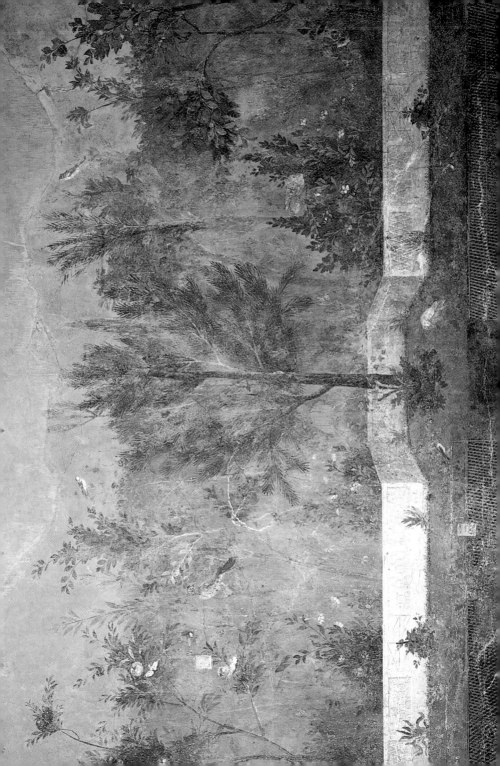

Glass Scent Bottle

THE ROMANS LEARNED THE ART of glassmaking, like so many other arts, from the Hellenistic world of the eastern Mediterranean that they absorbed. Small glass objects were being made in western Asia and Egypt by around 1500 B.C.; but it was not until a thousand years later that the use of glass for luxury objects such as beads and vessels for perfumes and oils became widespread throughout the eastern Mediterranean, with centers of manufacture in Rhodes, Cyprus, and Greece. The new city of Alexandria, founded in 332 B.C. by Alexander the Great, became a major source, exporting its wares to Greece and Italy. The new luxury items found special favor in Italy, and artists trained in Alexandria migrated to set up glassworks near Rome.

Many of the earliest glass vessels were modeled on the shapes of contemporary Greek earthenware vases. This brightly decorated perfume bottle, only six and a half inches high, is called an *amphoriskos*, after the Greek *amphora* or wine jar of which it is a miniature replica. The vessel, found in a grave in Cyprus, once stood on a base-knob, only part of which survives. As with other early vessels, the glass was not blown, but rather poured in molten form over a core of compressed mud and straw. Handles were added, and the vessel was then decorated by pressing lines of variously colored glass into the opaque surface. The yellow line on this perfume bottle is an unbroken spiral running from the lip to the shoulder. The white line also forms a continuous spiral from shoulder to base, but its lines have been combed upward with a sharp-toothed metal tool to form a characteristic looped pattern.

Second or first century B.C. British Museum, London

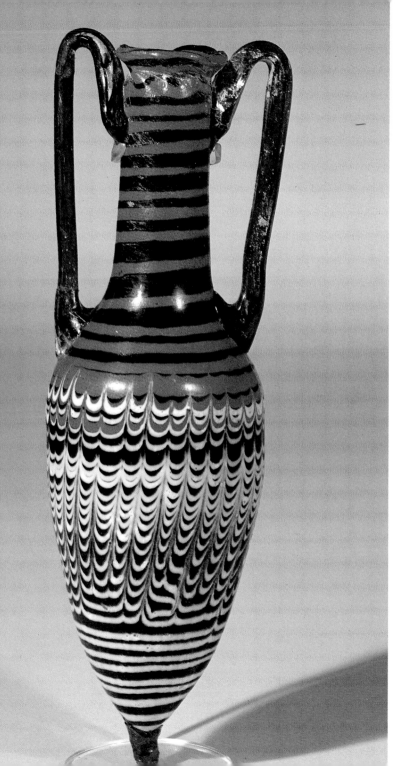

The Roman Forum

AT THE HEART OF EVERY ROMAN TOWN was the forum: a public square and marketplace, surrounded by buildings in which the administration of the city's affairs was carried on. Under the emperors, the Forum of Rome became not only the core of the city but the center of the entire Roman world. Successive emperors built outward from the original Forum Romanum to create a whole series of imperial forums, each one dotted with public works and memorials to their own greatness: temples and basilicas, baths and circuses, triumphal arches and monumental columns.

The structures shown here recall some 1200 years of Roman history, from the small Temple of Vesta, in the foreground, to the tall Column of Phocas, next to the triumphal arch in the background. The temple of Vesta, goddess of hearth and home, was rebuilt in marble around A.D. 200 on a site sacred to the Romans since before the foundation of the Republic. A sacred flame, tended by the Vestal Virgins, burned there night and day. Though its columned style is based on Greek forms, the circular shape of the temple may be derived from the round huts of Iron Age villagers, who were the earliest settlers in the vicinity of Rome.

On the left are three surviving columns, forty-seven feet high, of a temple of Castor, rebuilt by Tiberius in A.D. 6, before he became emperor. According to tradition, the first temple to Castor was built here in the early fifth century B.C., to honor the legendary hero who helped the Romans win a great victory over neighboring Latins on the banks of Lake Regillus. The sixty-foot triumphal arch in the background was built in A.D. 203 to commemorate victories won by the Emperor Septimus Severus on the Empire's eastern frontiers. Four carved panels over the flanking arches illustrate Septimus' conquest of Parthian cities in Mesopotamia and Babylonia.

The tall column visible between the Arch of Severus and the Temple of Castor is the Column of Phocas, one of the last additions to the Forum. It was built in A.D. 608, in honor of the emperor then ruling the surviving eastern part of the Empire from Constantinople.

First to seventh century A.D.

30

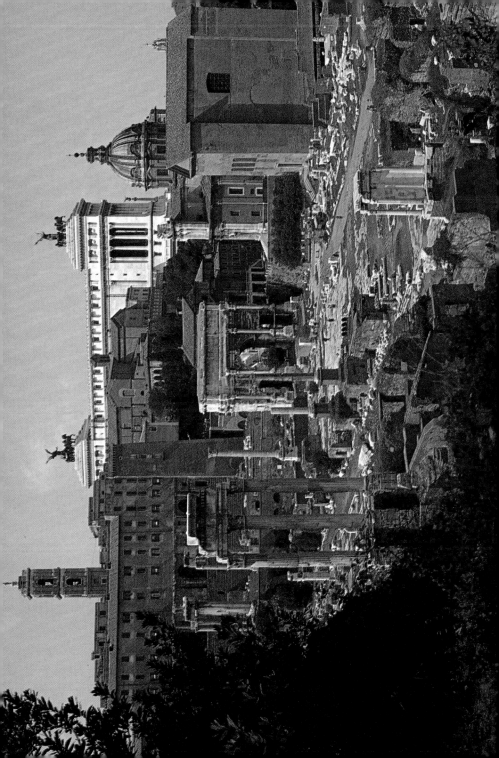

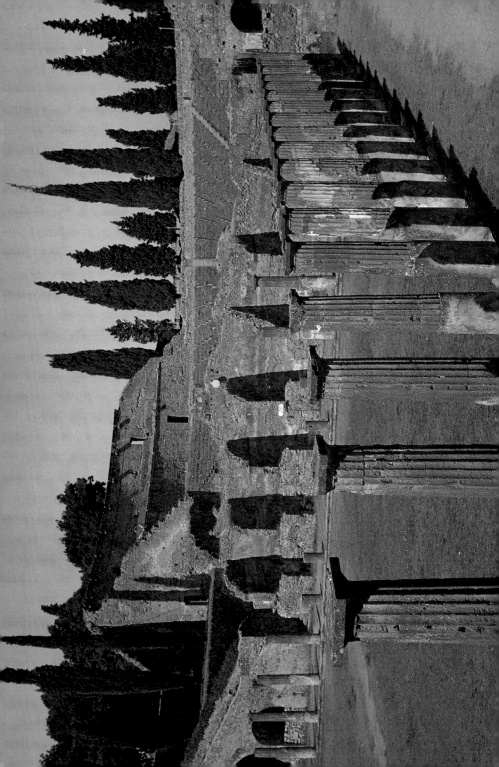

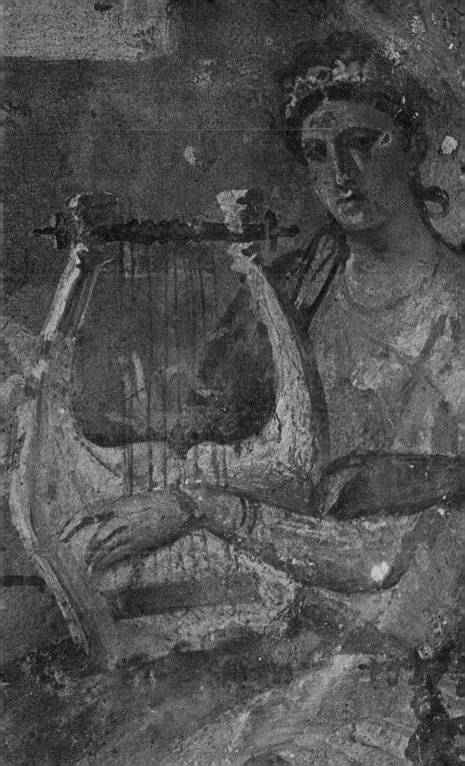

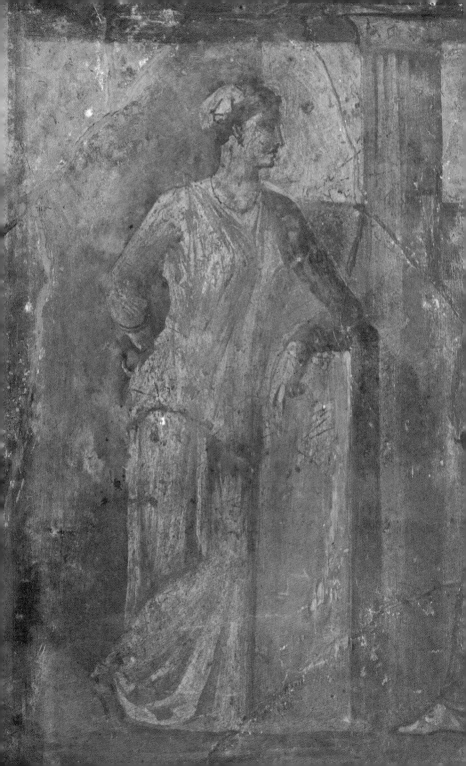

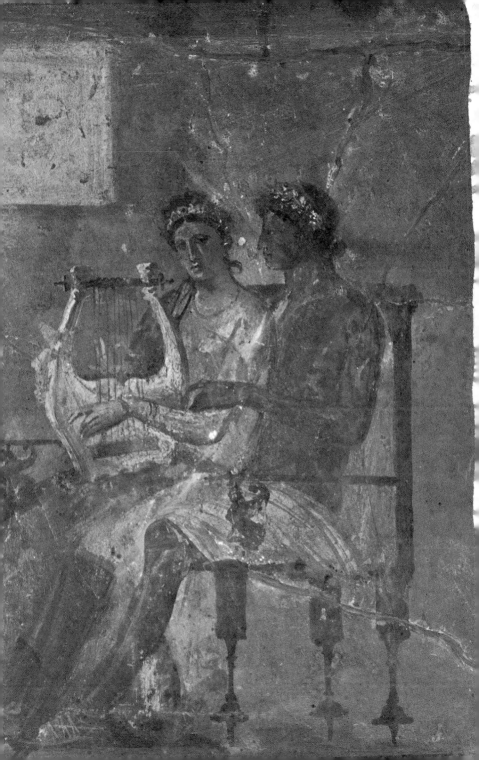

Gladiators' Barracks at Pompeii

THESE CLASSICAL DORIC COLUMNS once supported the roof of the barracks built for the gladiators of Pompeii. Every self-respecting Roman township had its own troop of gladiators, with a training school in which they learned how to fight in the arena. Good training could mean the difference between death in the first combat and survival for several; but most gladiators knew they were doomed to die eventually, and for this reason few among their ranks were volunteers. Slaves, prisoners of war, and lesser criminals made up most of their number. Some gladiators, victors of many combats, became popular heroes, and even a losing gladiator who had put up a good struggle might be spared to fight another day if the crowd showed its favor.

The instructors who ran the gladiators' training schools were experts at devising ever more bizarre types of contests to entertain the masses. The gladiator's conventional weapon was the *gladius*, or short sword, but often a conventionally armed gladiator would be pitted against a *retiarius*, who fought bareheaded and armed only with a fisherman's net and trident. Prisoners captured in war often used the weapons and armor of their native regions: the Thracian fought with a curved scimitar, the Samnite with ponderously heavy armor and a plumed helmet.

Behind the barracks, framed by the characteristic cypress trees of the south Italian landscape, rises the tiered seating of one of Pompeii's theaters. The entertainments staged here, though less gory than the *ludi* of the amphitheater in which the gladiators fought, were unsophisticated fare, seldom rising above the level of bawdy farce, mime, or burlesque.

A.D. 70

33

Music Lesson

MANY OF THE WALL PAINTINGS in the houses of Herculaneum and Pompeii depicted scenes from everyday life in the family home or in the streets and markets outside. Unearthed centuries later, their colors still bright, these paintings give a vivid glimpse into the lifestyle of the first century A.D. citizens of two wealthy Campanian towns. We see housewives shopping in the market, accompanied by slaves to carry their purchases; shopkeepers peddling their food and other goods in the Forum; men gambling over a form of backgammon in a tavern; a baker selling loaves across the counter of his shop.

This painted panel from a villa at Herculaneum, just over thirty inches wide, shows a typical domestic scene in the life of a well-to-do family. Watched by her mother, the daughter of the house takes a music lesson from her tutor, possibly a Greek. She is learning to play the cithara, a stringed instrument developed from the early Greek lyre. The lyre had a tortoise-shell soundbox, but the cithara's was made of wood to amplify the notes more strongly. The high-backed chair, with its decorative armrests and elegantly turned legs, was probably made of bronze; it indicates the opulence of the household.

Learning to sing and play a musical instrument was a part of every Roman girl's education. Though girls left school at thirteen, they continued to study music as part of their training to become good housewives. Running a home imposed considerable demands on the woman of the house, even though she had slaves to do the manual work. Lavish dinner parties lasting three hours or more were frequent occurrences, and after the banquet the women would provide musical entertainment.

First century A.D. British Museum, London

37

Roman Legionary

ROME'S GREAT EMPIRE was largely created and maintained through the might of the legions, vividly personified in this lifelike bronze miniature of a lone legionary. Though he is relaxed in pose, his rugged features and sturdy frame express the strength and pride of the highly trained and disciplined professional foot soldier. Although the figure is only six inches high, it gives a detailed picture of the characteristic armor of the Roman legionary in imperial times. To protect his shoulders and upper body he wears a cuirass formed of overlapping bands of iron, with leather backing and buckles. Below is a kilt made of hanging strips of leather, plated with metal. He has a helmet of bronze or iron, greaves to protect his shins, and sandals with thick leather soles. The legionary's full battle array also included a rectangular, semicylindrical shield or *scutum*, made of wood covered with leather; a throwing spear or *pilum*, wooden-shafted and iron-tipped; and a short stabbing sword, or *gladius*, suspended at the right hip, for the close-combat fighting that often decided the outcome of a battle. At his left hip he carried a *pugio* or dagger as an extra close-combat weapon or all-purpose knife.

In addition to the weight of his armor and weapons, the legionary also had to carry all the equipment necessary to make a fortified encampment wherever the legion stopped for the night. This included a spade with which to dig a defensive ditch and rampart, other tools such as a pickax and saw, and food for at least three days.

Each legion marched as a self-contained force under a commander of senatorial rank, and its complement of six thousand troops included, besides its fighting men, specialists such as mounted scouts and dispatch riders, engineers and surveyors, arrowmakers and medical orderlies. The legion was divided into cohorts of 600 men, further subdivided into six centuries, each containing about a hundred men under the command of a centurion.

Second century A.D. British Museum, London

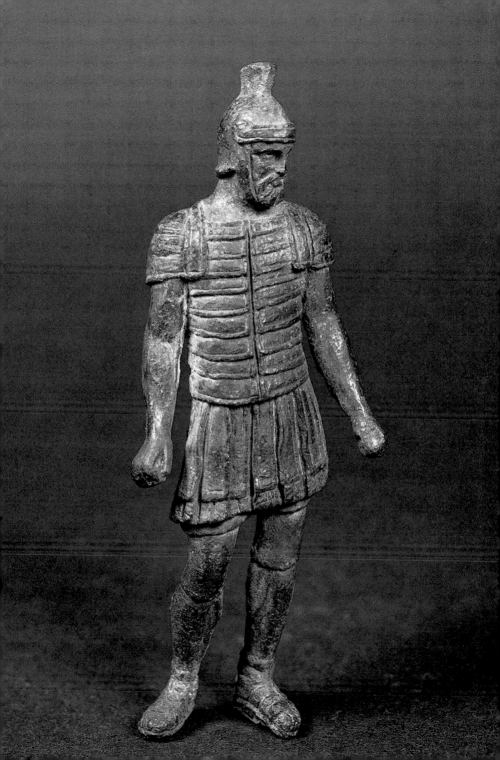

Colosseum of Rome

THERE EXISTED IN THE ROMAN CHARACTER a sadistic streak that could only be satisfied by public exhibitions of human and animal slaughter on a massive scale. The notorious *ludi*, or "games," were a staple form of entertainment for the Roman masses, staged in specially built amphitheaters in towns throughout Italy, the western Roman provinces, and North Africa. Most imposing of all these amphitheaters—and one of the most celebrated of all Roman buildings standing today—is the Colosseum in Rome, begun by the Emperor Vespasian and inaugurated during the reign of his son Titus in A.D. 80. Some fifty thousand spectators at a time could pack into the huge oval building; they entered through seventy-six arched gateways, then spread left and right along covered corridors to reach the terraced seating—marble on the lower levels, wooden above—which rose 160 feet from the floor of the arena to the roof. The oval floor of the arena has been excavated in modern times to reveal the vaulted underground cellars in which animals and people were kept before being taken to their deaths in the arena.

Amphitheaters such as the Colosseum were the scene of day-long orgies of killing, involving extremes of brutality that seem hideous today. In addition to the systematic slaughter of wild beasts by specially trained animal-fighters, animals were sometimes pitted against each other, or chained to stakes and baited by savage dogs. Armed gladiators engaged each other in fights to the death, while defenseless human victims—often Christians or criminals—were torn apart by lions and tigers.

A.D. 80

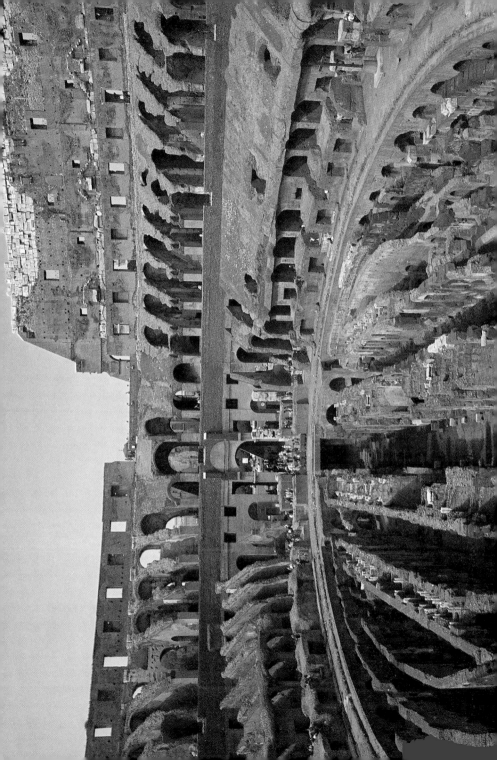

Medical Care in Ancient Rome

IN MEDICINE—as in most fields of scientific inquiry—the Romans looked to Greece for their tutors. The teachings of the fifth-century B.C. Greek thinker Hippocrates guided medical practice in early classical times; one of the most important successors to Hippocrates in extending the boundaries of medical knowledge was another Greek named Galen, born in Roman-ruled Pergamum in Asia Minor around A.D. 130. Physicians were brought from Greece to Italy in large numbers to minister to wealthy Romans. Other Greek doctors accompanied the legions on their campaigns as medical officers, assisted by a team of orderlies. They set up field hospitals where wounds were dressed, arrowheads removed, and limbs amputated. The Romans had little knowledge of drugs in treating illness, relying instead on herbal remedies and natural antiseptics such as pitch and turpentine.

The Romans' particular contributions to medicine lay in advancing public hygiene and the technology of medical treatment. They devised a form of artificial limb, and improved on the array of medical instruments already available. The collection of instruments shown here includes (from right to left): a spoon, for giving liquid medicines; a forked probe, for extracting an arrowhead or other foreign body from the flesh; a traction hook, for manipulating organs or tissues during surgery; a spatula, for applying and spreading ointment or for holding down a patient's tongue while examining his throat; a probe, for investigating a wound; a scalpel; and a large pair of tooth-edged forceps, probably for crushing tissue to prevent hemorrhaging after an amputation.

First century A.D. British Museum, London

42

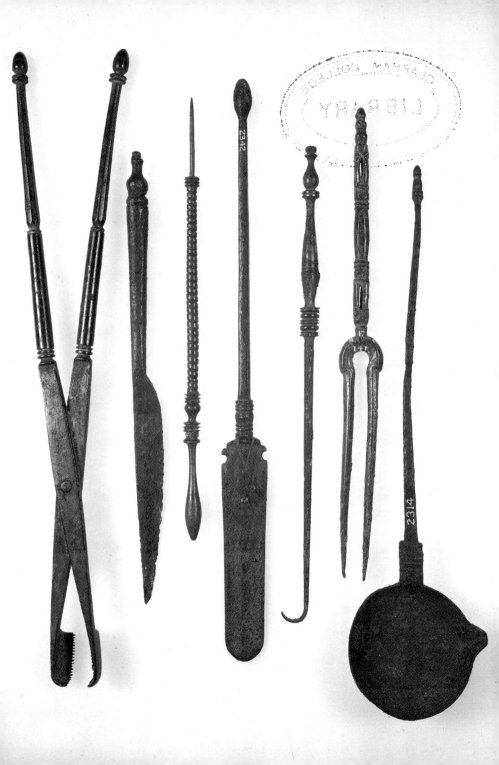

Helmet for the Military Games

THE HELMET of the ordinary legionary in Rome's armies was made of beaten bronze, descending low over the brow; hinged cheekpieces gave added protection to the face. But Roman bronzesmiths also supplied to the Roman army a quite different type of decorated helmet in which a molded mask covered the entire face. In this example, found in a tomb at Nola in southern Italy, the face is youthful and idealized. The chin is pointed, and a line of wavy curls escapes below the bonnet of the helmet. There are openings in the thin metal for the eyes, and narrow slits at the nostrils and mouth. The aperture at the top was probably designed to hold a crest of feathers.

Such visored helmets as these were worn not in battle but only during the special exhibitions of cavalry sports known as *hippica gymnasia*. At these tournaments, auxiliary horsemen attached to the Roman legions competed in javelin-throwing contests, using special light javelins. The riders belonged to cavalry units recruited from local tribes in countries where the legions were stationed, and their ethnic dress added color to the occasion. The horses, too, were elaborately decked with bronze eyeguards and embroidered cloths.

Cavalry sports may have been Greek in origin, or they may have been adopted from the Iberian and Celtic peoples whose lands the Romans overran; certainly the sports seem to have had a semireligious character. The idea of the face mask may have been derived from the state masks of Greek and Roman theater, and the helmets may have been molded to represent familiar dramatic characters.

First or second century A.D. British Museum, London

44

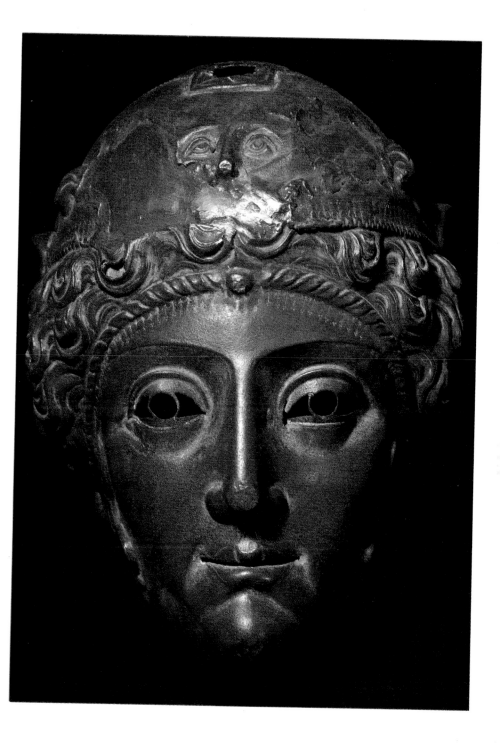

Aqueduct at Segovia

THE DEVELOPMENT OF THE ARCH to support huge structures was a Roman achievement, seen at its most spectacular in the soaring arches of the great aqueduct at Segovia, in northern Spain, which tower up to one hundred feet above ground level. The aqueduct, which is still in use today, runs for half a mile across the heart of Segovia on a line of 128 arches, carrying water from springs nine miles outside the city in an enclosed channel along the top. The tall arches are built up from roughly squared stone blocks, weighing up to fifty tons, which rest firmly upon one another without cement, creating a total impression of grace combined with massive strength.

The Romans completed their conquest of the Iberian peninsula in the time of Augustus, and brought to the province many of the typical features of Roman civilization, including roads, bridges, and a reliable water supply for their new towns. Roman builders were guided in their ambitious projects by textbooks whose authors were well versed in the principles of hydraulic engineering. In the time of Augustus, the Roman architect Vitruvius advised that the gradient of a concrete channel should be not less than one inch and not more than six inches for every hundred feet. Water pipes, said Vitruvius, should be of masonry or clay and not of lead; he based this advice on his observation of the poor health suffered by plumbers working with lead pipes. The engineering skill of Roman architects was complemented by an abundant supply of cheap labor. Armies of slaves captured in war toiled at the stone quarries; slaves and local craftsmen then hauled the great blocks into place with the aid of cranes, pulleys, and scaffolding.

First or second century A.D.

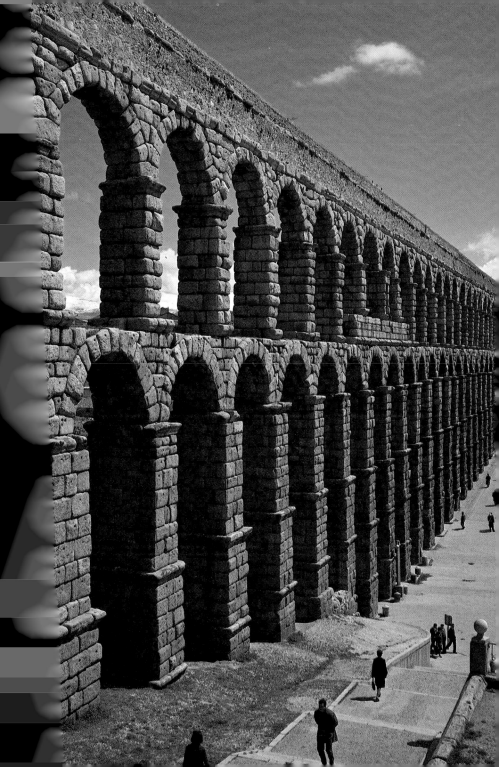

The Portland Vase

THE TECHNICAL SOPHISTICATION of the Portland Vase and the enigma of the scene depicted upon it have combined to make it one of the most intensively studied objects of the ancient world. The elegant vase and its cameolike decoration are made entirely of glass, and four separate stages were involved in its manufacture. A glassblower first blew the body of the vase from molten glass that had been colored cobalt blue by various oxides, and then encased the lower part of the vase within a layer of opaque white glass. To create the design, an engraver carved away the unwanted areas of white glass to leave the figures standing out in relief, and then modeled them in detail, using an engraving wheel, small chisels, and files. The entire vase as it survives today is only 9¾ inches high, but originally it probably tapered downward to a point and stood on a base-knob.

The two scenes depicted on opposite sides of the vase clearly represent an event from classical mythology; the most widely accepted interpretation is that they tell the story of the wooing of the sea-goddess Thetis by the mortal hero Peleus. According to mythology, Zeus and Poseidon both fell in love with Thetis; but because of a prophecy that Thetis would bear a son mightier than his father, the gods agreed that Thetis should marry a mortal rather than a god. Following this interpretation, the figure on the left would be Peleus stepping forth from the shrine of Aphrodite, the goddess of love. Eros, holding a bow and a torch, flies ahead, looking over his shoulder to make sure Peleus is following. On the ground sits a female figure, also urging Peleus on; the sea serpent between her knees identifies her as a sea-goddess, probably Thetis' mother Doris. The bearded man on the right, also watching Peleus, is taken to be Nereus, the father of Thetis.

The subject chosen for the design, of a wooing blessed by the presence of the deities of love and marriage, suggests that the vase may have been intended as a wedding present for some unknown Roman patron; the excellent workmanship suggests it could be the work of craftsmen who had moved to Italy from the important glassworks in Alexandria. The vase takes its modern name from the English family that owned it for 150 years.

First century B.C. or first century A.D. British Museum, London

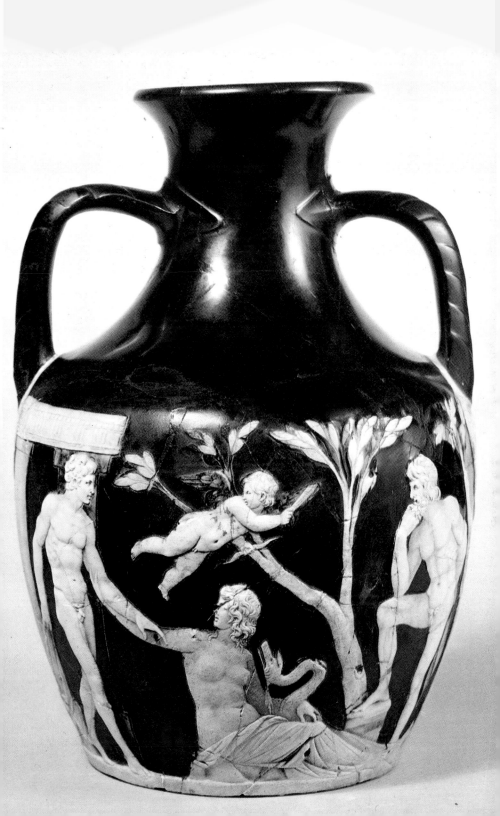

Bacchic Procession

AS THE GOD OF WINE AND THE GRAPE, the Greek Dionysus had a strong appeal for the wine-loving Romans, who knew him as Bacchus. However, the orgiastic ceremonies that accompanied the worship of Dionysus in Greek times were less in tune with the more austere temperament of republican Rome. Frenzied Bacchanalian revels did occur from time to time in Rome, and the worship of Bacchus was for a period forbidden by law; but in later times his cult appears to have taken on the status of a mystery religion, comparable with other cults introduced from the eastern provinces. To the Greeks' simple deity of wine and revelry the Romans added more complex attributes, making Bacchus a god of fertility and regeneration who was honored with rituals known only to initiates.

That the earlier, more abandoned nature of Dionysiac worship was not forgotten is shown by this marble relief, carved about A.D. 100 but probably based on a classical Greek model of five centuries earlier. It shows a Bacchic procession, led in traditional manner by a *maenad*, a woman attendant of Bacchus. She throws her head back in an attitude of ecstatic possession and clashes a pair of cymbals. Following are two satyrs, male attendants of the god with animals' tails, one blowing a double flute and the other holding a *thyrsus*, a staff topped by a pine cone. Alongside paces a panther, an animal sacred to Bacchus. The relief was found on the wall of the Villa of the Quintilii, on the Appian Way two miles south of Rome.

A.D. 100 British Museum, London

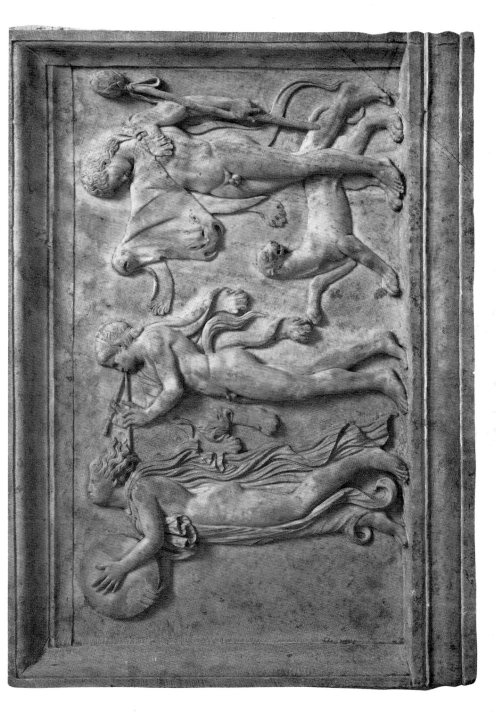

Alexander the Great

IN BUILDING THEIR OWN MIGHTY EMPIRE, the Romans looked back with awe upon the single most successful empire-builder in history. This was the dashing figure of Alexander the Great, the young Macedonian king who, in a campaign lasting only eleven years, created an empire that stretched from Greece southward into Egypt and east as far as the Indus River. This miniature bronze figure, six inches long and four and a half inches high, probably represents Alexander. It is cast in relief, with a hollow back, and was probably intended to be a decoration for a general's cuirass—a sign of the respect in which Roman generals held their illustrious predecessor. As such, it may well have been worn in one or more of the battles by which the Roman legions made themselves the new masters of Alexander's domains, three centuries after his death.

Alexander's career of conquest was sparked off by the ambition of his father, Philip of Macedon, to unite the rival city-states of Greece and lead them against Persia, their traditional enemy. Philip was killed before he could fully realize his ambition, but Alexander achieved all that his father had set out to do—and more. In 334 B.C. he crossed into Asia and attacked the Persian Empire, completing its defeat within six years. He did not stop with the subjugation of Persia, but pressed on eastward to make all western Asia part of the Greek world. Alexander died in Babylon in 323 B.C. at the age of only thirty-one, after which his generals divided his territories among themselves and established three great dynasties to rule them. In the course of time political rivalries developed between the Macedonian kingdoms, into which Rome, as the rising power in the Mediterranean, was inevitably drawn. The kingdoms fell one by one to the might of Rome, but the Greek culture they had absorbed during the Hellenistic age since Alexander's death cast its spell on the Roman conquerors, and gave them in their turn a respect and admiration for all things Greek.

Second century A.D. British Museum, London

FOLD OUT HERE

Mummy Portrait of a Roman Matron

As THEIR EMPIRE EXPANDED, the Romans influenced the arts and traditions of the lands in which they settled and gave them a recognizably Roman character. Egypt, controlled since the death of Alexander the Great by rulers of the Ptolemaic dynasty of Macedonian Greeks, finally came under Roman rule after the defeat of Antony and Cleopatra at the sea battle of Actium in 31 B.C. For thousands of years Egyptians had enclosed the mummified corpses of prominent men and women within one or more mummy-shaped wooden cases, decorated with stylized representations of the dead person and mythological scenes and symbols. Under Roman rule, the practice of mummification continued, but the representation of the dead person became a lifelike portrait, painted on wood and laid within the mummy case. Such portraits were comparable in their realism to the marbles and wall paintings produced by artists of the time in their Italian homeland.

This coffin portrait is one of a large collection found at Hawara, in the area now called El-Fayyum. It was painted by a technique known as encaustic, using colors mixed with melted wax; they have retained their brightness undimmed through the centuries.

The realism with which the artist has depicted the elongated head and wide dark eyes of this wealthy matron extends to the rendering—precise as an inventory—of the jewelry she wore in her lifetime. Individual gems can be identified with near certainty. The hooped earrings are set with three precious stones, apparently emeralds or beryls. The same stones, separated by gold spacers, form the upper necklace. The lower necklace is a chain of beads, alternately gold and garnet; at the center is an emerald or beryl medallion from which hang two pearl pendants.

Second century A.D. British Museum, London

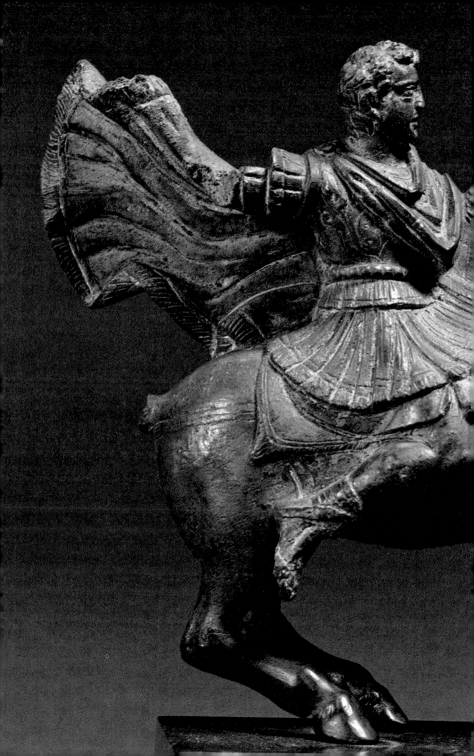

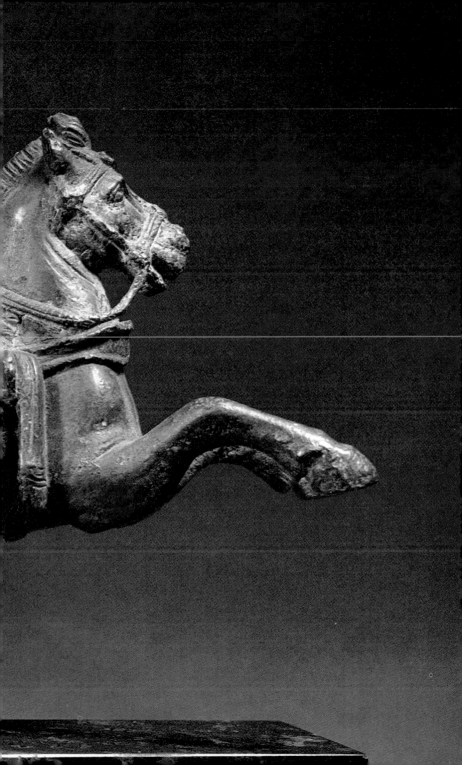

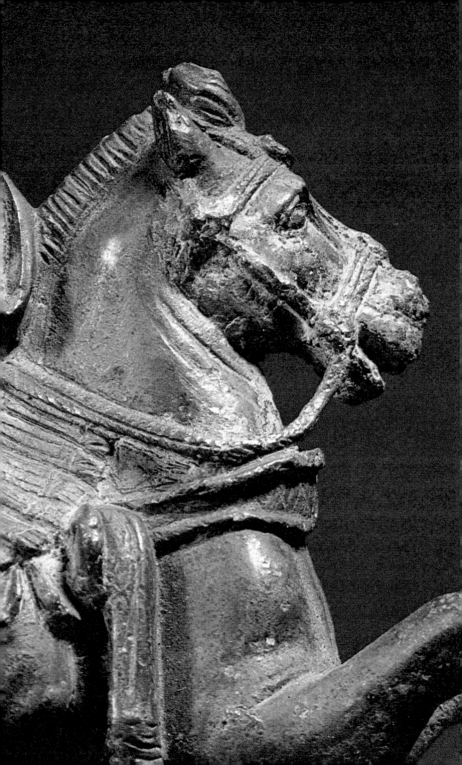

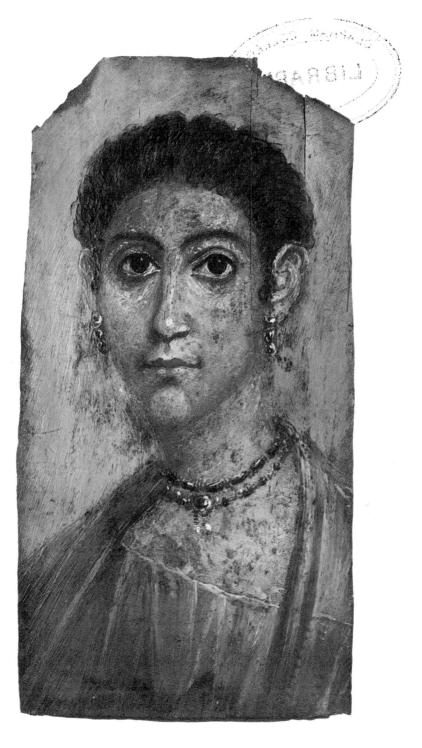

Nero as Alexander

THIS BRONZE STATUETTE of Nero represents the notorious emperor in a kinder light than the portraits on the coins of his reign and the stories told of his debauchery and tyrannical rule. Here he is a virile general in battle armor, his hand raised to hold a spear or scepter (now lost). The youthful classical features suggest that the artist was deliberately flattering his subject by portraying him in the guise of the victorious Alexander the Great. The figure, twenty inches high, was found in Suffolk, England. The glorification of Nero doubtless had a propagandist purpose, for Nero's reign saw troubles for the Romans in their new province of Britannia. In A.D. 60 Queen Boudicca led a revolt of the Iceni tribe, which destroyed three major cities and for a while threatened to expel the Romans altogether from the island, to which they had come in force only seventeen years before. That the statuette was made in Gaul or Britain and not in Rome is further indicated by the typically Celtic geometrical decorations, in silver and niello inlay, with which Nero's cuirass is adorned.

Most Roman bronzes were produced by the "lost wax" method. The figure was modeled either in wax or in clay covered with wax, and was then coated with clay to form a mold. The figure was then heated, allowing the wax to run out through holes in the casing, and the resultant cavity was filled with molten bronze. This could produce either solid figures or hollow-cast figures, from which a clay core was subsequently removed. Large figures were often cast in several pieces, which were then riveted together or fused with molten metal. The head, arms, and body of this statuette of Nero were cast separately; the joint between head and body is visible around the top of the cuirass. The welding that joined the left arm to the body proved inadequate, and the arm has been lost.

Mid-first century A.D. British Museum, London

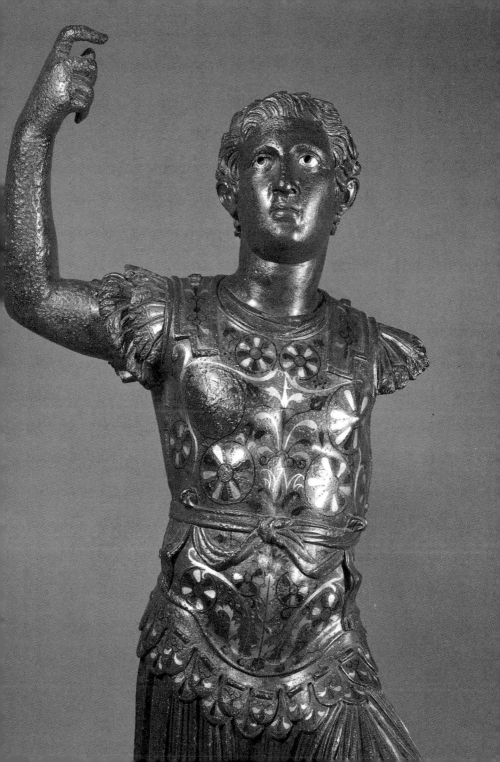

The Pantheon

THROUGH A CIRCULAR OPENING at the apex of the soaring dome, a shaft of light provides the only illumination for the interior of one of the architectural masterpieces of the ancient world. The Pantheon of Rome was inspired by the emperor Hadrian as a temple honoring all the gods of the Roman Empire, and its impressive dome, rising to 142 feet above the floor of the temple, was constructed of a tough new building material barely exploited by previous civilizations: concrete. Known to the Romans as *opus caementicium*, concrete was made from a mixture of mortar and lumps of aggregate. It was laid in horizontal courses, with outer facings of stone or baked brick. The strength of the structure, when supported on stone or concrete piers, enabled Roman architects for the first time to enclose wide spaces with self-supporting vaulted roofs.

Below the circular opening, twenty-seven feet across, the inside surface of the Pantheon's dome is broken up by rectangular recesses. These coffers—small near the top, larger lower down—decorate the ceiling and also distribute the weight of the concrete. The dome is supported on a circular drum with walls twenty feet thick, and the whole structure rests on a ring-shaped foundation extending fifteen feet below the ground. Precise symmetry is a feature of this remarkable building: its diameter at floor level is exactly the same as its height from the floor to the apex of the dome. An illusion of even greater breadth is created by skillfully placed niches set into the walls and fronted by tall fluted Corinthian columns. It was a measure of the genius of Hadrian's architects that they could blend startling new construction techniques with the decorative features of an older architectural tradition, creating a uniquely satisfying and harmonious whole.

A.D. 118–128

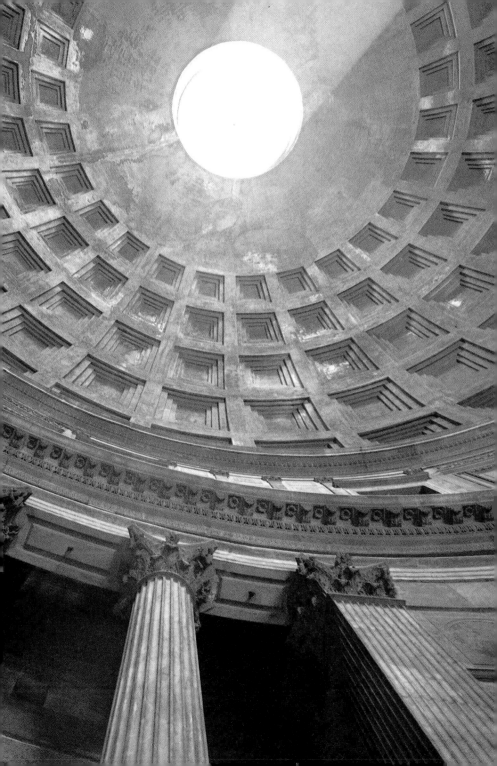

Hadrian

In A.D. 117, the Spanish-born emperor Hadrian inherited a Roman Empire that had been enlarged by his predecessor Trajan to its greatest extent thus far. Much of Hadrian's twenty-one-year reign, from A.D. 117 to 138, was spent in consolidating Rome's hold on its huge domains. For more than thirteen years he was absent from Italy, traveling thousands of miles throughout the Roman world to inspect and strengthen the frontiers of the empire. The seventy-three-mile wall across northern Britain, built to keep barbarians out of the Roman-held south, is the most notable of his military achievements. Aside from his success as a general, Hadrian was devoted to the arts as well. He painted, wrote poetry, and sang; and on his visits to the outermost provinces of the Roman world he took pains to encourage local art and architecture. Hadrian founded new cities in Asia Minor and Egypt, and in established cities such as Athens and Ephesus he instituted ambitious programs of public building. At home in Italy, he built himself a palatial villa on a 150-acre estate at Tivoli, just outside of Rome.

This portrait bust of Hadrian captures both the military and artistic sides of the emperor's character, showing him with the decorated cuirass of a Roman general and the elaborately curled locks and beard of a Greek god or philosopher. Hadrian was an admirer of Greek culture, earning for himself the title of Graeculus, or "Little Greek," and under his influence Roman art enjoyed a classical Greek revival. The reintroduction of the beard into male portraiture contrasted sharply with the clean-shaven style of earlier Roman portraits. In this particular aspect, Hadrian's admiration of Greek art retained its influence on Roman art for two hundred years after his death: during this time all notable male personages were portrayed with beards.

c. A.D. 120 Capitoline Museum, Rome

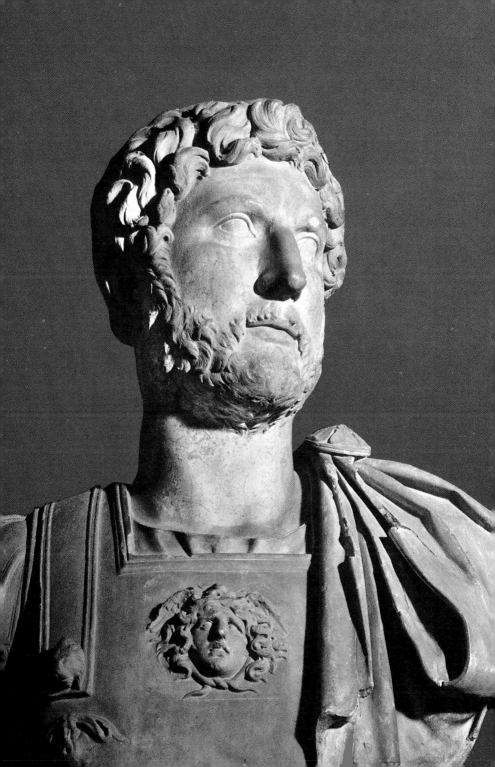

Castel Sant' Angelo

THE LONG AND STABLE REIGN of the emperor Hadrian in the second century A.D. gave Rome a wealth of spectacular new buildings. One that is as much a landmark of the modern city of Rome as it was in antiquity is the great mausoleum that Hadrian designed for members of the imperial family. The circular tomb, now the Castel Sant' Angelo, is 210 feet in diameter and rises 100 feet above the bank of the River Tiber. In ancient times the stonework was faced with marble and adorned with statues and gilded decorations. On top stood a huge statue of Hadrian; he was probably shown driving a four-horse chariot in the manner of the Asian ruler Mausolus, whose great tomb at Halicarnassus—one of the Wonders of the Ancient World—gave the name of "mausoleum" to this type of monumental burial place.

Hadrian's mausoleum was not completed until the time of his successor, Antoninus Pius. It remained in use as an imperial tomb for nearly a century. Later it was used as a prison and bridgehead fortress, and in the Middle Ages several popes used the building as their personal stronghold and made extensive alterations. Today the Castel Sant' Angelo houses a museum.

The bridge that sweeps across the Tiber to the Castel Sant' Angelo also dates back from Hadrian's time and was probably the work of the same architect, Demetrianus. The emperor gave the bridge his own family name of Aelius. The graceful arches and the strong cutwaters, or piers, which protect the arches against the strong current, typify the bridge-building skills perfected by the Romans in early republican days. So important were bridges to the growth of Rome—situated as it was at the only point on the lower Tiber that could be bridged—that the spiritual head of the infant city became known as Pontifex Maximus, or "Chief Bridge Builder," a title still borne by the Pope today. The Pons Aelius was enlarged in Renaissance times to the design of Bernini, who added the parapets and the statues of angels.

A.D. 135–139

64

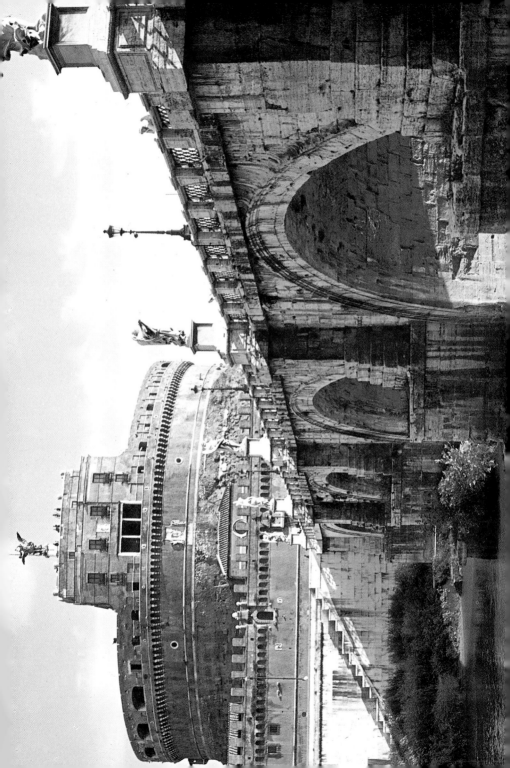

Guardian of the Household

THE ROMANS PRESENTED a public image of a hard-headed, materialistic people: skilled engineers and tough soldiers, shrewd politicians and efficient administrators. Yet in his private life the average Roman was prey to a thousand superstitions and believed that supernatural forces watched over every aspect of his daily life. To ensure that the influence of these forces was friendly and not hostile, numerous rituals, both private and public, had to be observed.

Nearly every Roman household contained a statuette of the Lar, guardian spirit of the household and its fields. Belief in such a spirit may well date back to the Romans' earliest beginnings as simple farming settlers by the River Tiber. This bronze Lar, six inches high, is dressed traditionally, in a short tunic with swirling skirt. He holds a *rhyton*, or horn-shaped drinking vessel, in his upraised left hand; in the other is a shallow *patera*, a vessel used for pouring libations.

Joined together with the Lar in the Roman's household pantheon of gods were the Penates, companion spirits who guarded the household's food supplies and were propitiated by food offerings at mealtimes. Statuettes of Lares and Penates often stood in a special shrine just inside the door of a house, where the family could pay respect to them on entering and leaving. The shrine was often a miniature replica of the temple in which priests made public offerings to Rome's state gods.

A third spirit associated with the household was Vesta, goddess of the hearth, which was the center of Roman family life. All of these private household spirits also had a public role. The Lares were guardians of Rome's roads and of the wayfarers who passed along them. The Penates were protectors of the well-being of the state, as well as that of individual families. Vesta became the goddess of the corporate "family" of all Rome's citizens, and was honored by an everlasting flame within a special sanctuary in the Roman Forum.

Second or third century A.D. British Museum, London

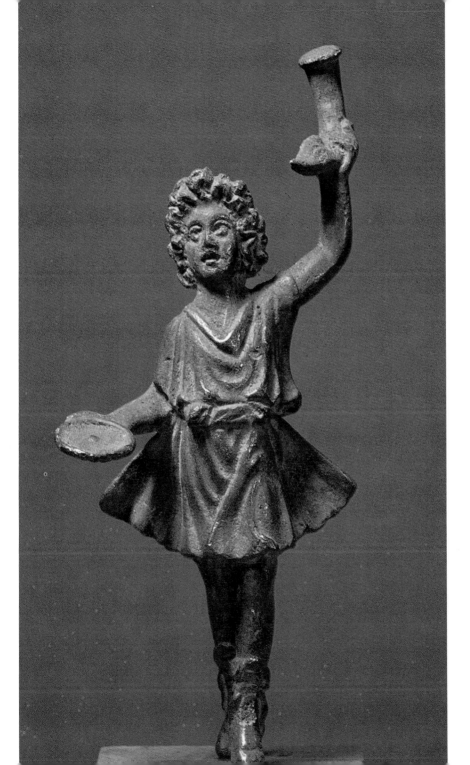

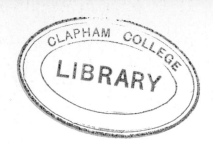
Great Bath at Aquae Sulis

WHEN, IN THE EIGHTEENTH CENTURY, England's fashionable society began to flock to the spa town of Bath to take the waters, they were reviving a practice that had been popular throughout the Roman occupation of Britain 1300 years earlier. The Romans built their city of Aquae Sulis—"the waters of Sulis"—around hot springs sacred to the Celtic water goddess Sulis, and by the end of the first century A.D. the town was a flourishing spa. Under the pillared colonnade around the Great Bath, which still stands today, Romans and well-to-do Britons strolled, exercised, and exchanged gossip. The rectangular pool itself, eighty feet long, forty feet wide and six feet deep, is still lined with the original Roman lead, and 250,000 gallons of mineral-rich water still gush daily from the hot springs, just as they did in Roman times.

To the Romans, public bathhouses were among the necessities of civilized living, serving not only a hygienic function but also as social and recreational centers. By the end of the third century A.D., Rome itself had nearly a thousand separate bathhouses. Most Romans visited the baths at least once a day to bathe, exercise, and meet their friends. The baths consisted of a series of rooms heated to various temperatures by hot air, which flowed through tiled ducts from an external furnace and issued through vents in the walls. From the *tepidarium*, or warm room, the bather passed to the *caldarium*, or hot room, and, if he wished, to the even hotter *laconicum*. He splashed water onto himself from the basins provided in each room, then cleansed his body by scraping off the sweat and dirt with a *strigil*, or bronze scraper. To finish his bathing he reversed the process, passing from hotter to cooler chambers; finally he could swim in the *frigidarium*, or cold pool, to close the pores of his skin before massaging it with oil.

Second century A.D.

68

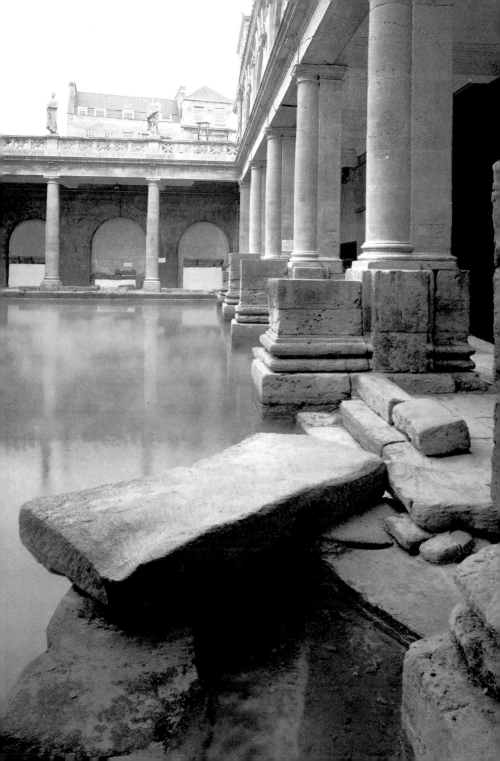

Cleanthes, the Stoic Philosopher

THE RICH ARTISTIC ACHIEVEMENTS of the Hellenized world the Romans conquered led to an enormous demand among wealthy Roman patrons for marble and bronze sculptures based on Greek originals, or even direct copies of earlier Greek works. Indeed, many of the finest works of Greek sculptors are known to us today only through copies made in Roman times. This brooding figure in bronze, thought to represent the Greek philosopher Cleanthes, is probably a copy of a Greek work of about 250 B.C.

Cleanthes was born in 331 B.C. and became a pupil of the philosopher Zeno, founder of the Stoic school of philosophy. Stoicism, today a byword for patient acceptance, constituted to Greeks and Romans an all-embracing system of ethics. To the Stoic, virtue was the supreme good and it was the duty of the wise man to live his life in its pursuit. Emotions had to be repressed to the point where a man became indifferent to joy or sorrow. Stoicism remained a major influence throughout the Classical world for six hundred years; its stern advocacy of self-control and the path of duty gave it a particularly strong appeal to the Roman temperament. Cleanthes showed his own moral fiber by working as a manual laborer all night to support his philosophical studies during the day. He succeeded Zeno as master of the Stoic school, and died at the age of ninety-nine.

First to third century A.D. British Museum, London

Lighthouse at Dover

IN THEIR CONQUEST OF BRITAIN, through a campaign lasting just over forty years, the fighting strength of the Roman legions was backed up by the skill of military engineers, who built fortresses to consolidate the Roman holdings and a network of roads to link them. To integrate Britain with the remainder of the Roman Empire, communication had to be maintained with the European continent. Vessels were soon plying back and forth across the English Channel, bringing reinforcements to the legions and supplies of wine, oil, and luxury goods from the Mediterranean, and taking back to Rome agricultural produce from the new northern province.

A surviving by-product of this cross-Channel traffic was this octagonal *pharos*, or lighthouse, at Dover in Kent. Dover, known to the Romans as Dubris, was one of the most important ports of the new province due to its strategic location at the southeast tip of the island, at the British end of the shortest cross-Channel sea route. To guide ships into safe anchorage at Dubris, Roman engineers constructed two lighthouses, one on each side of the harbor. A fire burned in an open brazier at the top of each lighthouse, giving smoke by day and flame by night, and ships' captains set their course midway between the two beacons. The surviving portion of the *pharos*, on the eastern side of the harbor, stands just over sixty feet high; the original building was probably twenty feet higher. The name *pharos* is derived from the island of Pharos off the coast of Alexandria in Egypt. A pyramid-shaped lighthouse of white marble built on the island in the third century B.C. was regarded as one of the Wonders of the Ancient World.

First or second century A.D.

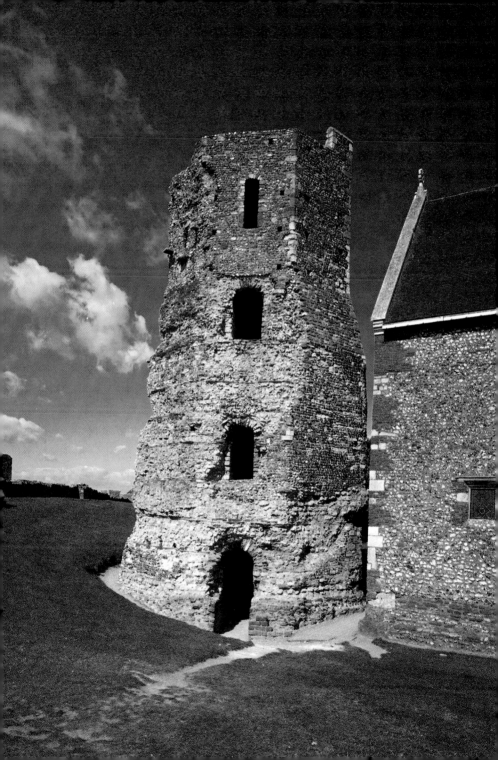

Marcus Aurelius, Philosopher-Emperor

AT THE HEIGHT OF ITS POWER in the second century A.D., Rome was ruled for twenty years by an emperor whom history remembers as much for his philosophical writings as for his administrative achievements. Marcus Aurelius was born in Spain, and succeeded to the imperial throne on the death of Antoninus Pius, his adoptive father. This fine bronze statue of Marcus Aurelius on horseback depicts the emperor as thin-faced, with curly hair and a full beard, clad in the soldier's garb of tunic and riding cloak. His eyes are contemplatively downcast, and his hand is outstretched as if to acknowledge the salute of his victorious legions. The statue, nearly seventeen feet high, was originally gilded, and was placed by Michelangelo to form the centerpiece of his Piazza del Campidoglio on the Capitoline Hill in Rome.

At the start of his reign Marcus Aurelius entrusted the leadership of Rome's armies to Lucius Verus, a second adopted son of Antoninus Pius. Verus put down rebellions in the eastern provinces until his death in A.D. 69. The following years saw a wave of threats to the northern borders of the Empire, and Marcus Aurelius himself spent much of the latter part of his reign campaigning against barbarian invaders from across the Rhine and Danube frontiers. He still found time, however, to set down his famous *Meditations*. Written in Greek, these form a memorable expression of the philosophy of Stoicism—based on the pursuit of virtue and rigid self-control—by which Marcus Aurelius regulated his own life. This equestrian statue, the finest of its type surviving from Roman times, conveys both the military and meditative aspects of Rome's philosopher-emperor.

c. A.D. 164

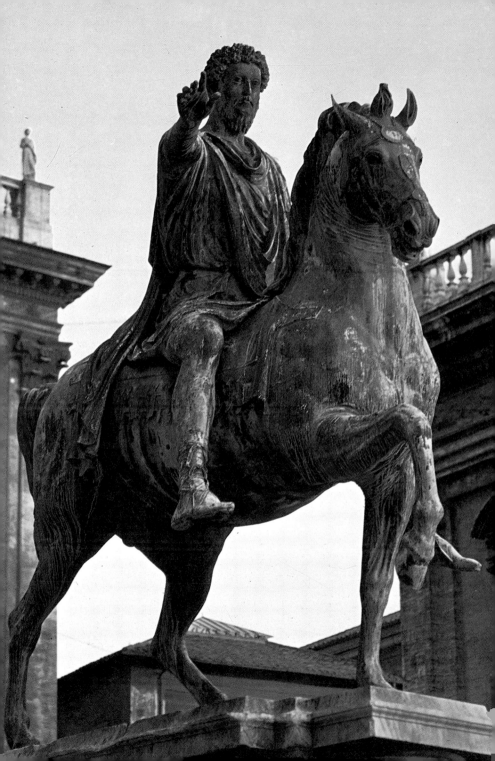

Temple in Tunisia

AGAINST A SOMBER NORTH AFRICAN SKY rise the limestone Corinthian columns of the Capitolium at Thuburbo Maius, thirty miles south of Tunis. Characteristically, the temple was built atop a high podium or base; a wide flight of steps at the front gave access to the temple, while the openings at the back of the podium, visible here, were used as storerooms.

Every sizable Roman town had a Capitolium honoring the three supreme gods of the Roman state: Jupiter, Juno, and Minerva. Jupiter was the father of the gods, analogous to the Greeks' Zeus; Juno, his consort, was the goddess of marriage; Minerva was the goddess of wisdom and of war. The Capitolium was named after the Capitol Hill in Rome, where this trinity of deities was first worshipped.

Like many Roman towns in North Africa, Thuburbo Maius grew up on the site of a much earlier settlement. The unusual name of the town indicates its origin as a village of the native Berber tribesmen. Later it belonged to the Carthaginians, whose empire the Romans conquered in the second century B.C. A colony of ex-legionaries from the Roman army was established at Thuburbo Maius as early as 30 B.C.; by the second century A.D. the town had its own Capitolium with a broad forum in front of it, several other temples, bathhouses, a theater, and numerous private houses with fine mosaic floors. Thuburbo Maius served as a market center; grain from Rome's North African provinces was gathered there and assessed for taxation before being carried to the coast for shipment to Rome. It was also a center of olive oil production, and in later years an olive press was set into one of the storage spaces in the podium of this temple.

A.D 167–168

Satyr Mask

THE PART-HUMAN, PART-ANIMAL SATYR, a spirit of the woods and companion of the wine god Bacchus, was a figure of classical mythology who appears in countless vase-paintings, reliefs, and sculptures of Greek and Roman times. Satyrs were depicted in numerous guises and engaged in a variety of activities. Usually they are shown with human bodies and faces and, in addition, long pointed ears, horns sprouting from their brows, and the tails of goats or horses. As companions of Bacchus—whose Greek equivalent was Dionysus—the satyrs were devoted to sensual delights, and are frequently represented engaged in drunken or lecherous revels.

Here the head of a satyr is sculptured in marble to form a decorative feature on the outside wall of a Roman public building. The lifesize head is carved in the form of a theatrical mask, such as was worn by performers in Greek drama to identify the principal attributes of the characters they were playing—child or adult, man or woman, hero or villain. The gaping mouthpiece probably acted as a megaphone to carry the actor's voice to the far corners of the huge open-air auditorium. The satyric mask was especially common, since one of the sources of Greek drama is said to have been a tradition of seasonal rites honoring Dionysus, in which dancers representing his attendant satyrs played a prominent part.

First or second century A.D. British Museum, London

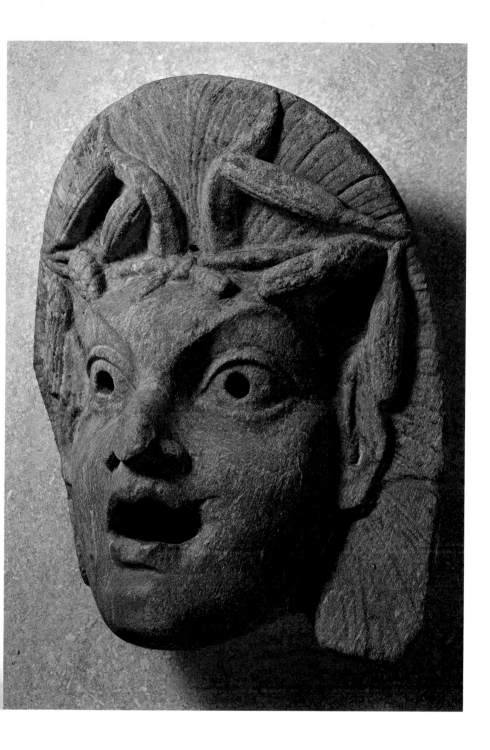

Theater in Africa

SILHOUETTED AGAINST THE GREEN BACKCLOTH of the Tunisian coun-
tryside are the tall columns of a theater set into a hillside on the out-
skirts of the Roman town of Dougga. The columns were part of the
scaenae frons, or permanent background to the stage, which once
rose to at least twice its present height. Actors came onto the stage
through the three openings between the sets of columns. The tiered
seats could accommodate 3,500 spectators, who entered through the
arches at left and right of the auditorium. The stage had a permanent
wooden roof, from which a temporary awning could be stretched
across the auditorium to shelter spectators from sun or rain.

The Roman theater had its origins in the Greek theater, which was
in the earliest days a circular open-air dancing floor, or *orchestra*,
with a central altar; in course of time one side of the *orchestra* was
developed into a raising acting area. In Roman times the stage became
the focal point of the theater, and the architecture of the *scenae frons*
became more and more elaborate, providing an early form of stage
scenery. The *orchestra* was reduced to a small semicircular area at the
foot of the stage, where visiting dignitaries could sit on wooden
benches.

The entertainment offered in the Roman theater showed a decline
from the classical drama of Greek times. In the days of the Empire,
when the theater at Dougga was built, the main fare was a type of
popular entertainment in which mythological stories were acted out
in burlesque form or mimed by a sole *pantomimus*, "imitator of all
things," to a musical accompaniment. Some of the brutality of the
amphitheater spectacles spilled over into the theater, too, in crude
dramas that were a mixture of cruelty and violence.

A.D. 150–170

80

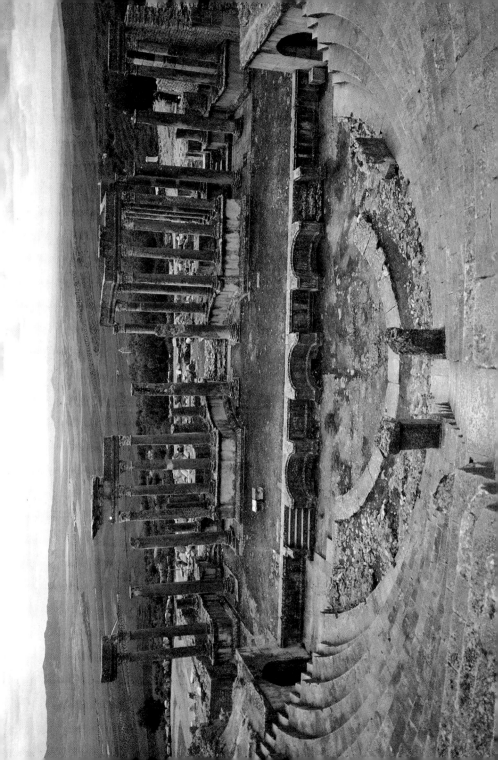

Cupid, Mischievous God of Love

LIKE SO MANY SCULPTURES of Roman times, this statue of Cupid is clearly inspired by a Greek original: the facial features and the nude figure bear the serene, idealized stamp of Classical Greek art. Cupid was the Eros of Greek mythology, Aphrodite's son and the god of love. He was traditionally represented as a beautiful youth who flew on golden wings, armed with the characteristic "cupid's bow" that curved inward at the center. He had the power to afflict those at whom he fired his arrows with the pangs of love, and many legends tell of the mischievous ways in which he misused this power.

Though the subject of the two-foot-high statue is a figure of a centuries-old tradition, its sculptor was clearly working in Roman imperial times. This is shown by the skillful way he has used the bow drill, as well as the chisel, to add depth to the detail of Cupid's hair and wings, and by the high polish he has given to Cupid's flesh by smoothing the marble with powdered pumice or emery. As in many Greek and Roman marble statues, the tree trunk—draped here with a lion's skin—served a practical purpose, giving support to the weight of the solid marble.

Second century A.D. British Museum, London

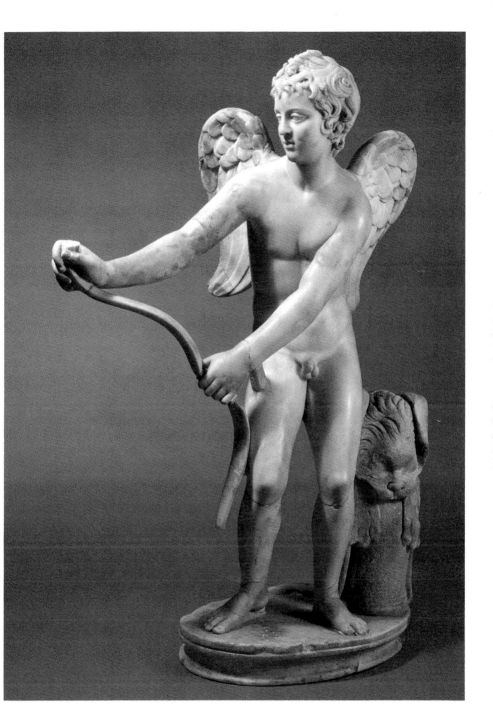

Amphitheater in North Africa

THE ROMAN PROVINCES in northern Africa were a major source of the wild animals—lions, rhinoceroses, elephants—that were slaughtered by the thousands in huge amphitheater spectacles to entertain the Roman populace. But not all the animals trapped in Africa were shipped to Europe; more than twenty amphitheaters were built in the African provinces, and similar bloody spectacles were the staple fare in them as well. The largest of these African amphitheaters was in the Roman city of Thysdrus, and its brown stone walls still rise to 100 feet above the present-day Tunisian village of El Djem. The oval arena is 660 feet long and more than 400 feet across at its widest point. Spectators sat on three raked terraces, which were reached through arched entrances from a covered arcade that ran all around the building.

With a capacity of fifty thousand spectators, the amphitheater at Thysdrus was equaled in size only by the Colosseum in Rome, and reflected the importance of Thysdrus as a major commercial center (primarily for olive oil, produced in the surrounding area). In A.D. 238 this African city became the focus of a political coup that shook the entire Roman world: the nobles of Thysdrus instigated a revolt against the Roman emperor Maximus, which led to the establishment of Gordianus, proconsul of Africa, on the imperial throne. Gordianus committed suicide within a few weeks and his son was killed in battle; but his grandson reigned for six years as Gordianus III.

A.D. 190–240

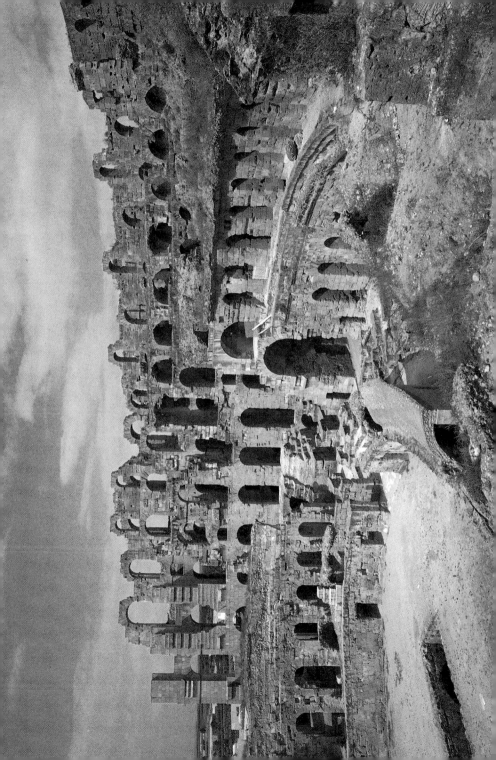

Art of the Glassblower

THE REVOLUTIONARY DISCOVERY that vessels could be made by blowing through a pipe into a blob of molten glass occurred about 50 B.C., probably in Syria. Centers of glass production had been established in the eastern Mediterranean for several centuries, but hitherto glass objects had been made by molding molten glass around a mud core. This slow and laborious process limited the use of glass to small luxury articles such as beads and toilet vessels; the simple new technique of glassblowing meant that glass could now be used for everyday domestic articles.

Within a century the new technique was firmly established, and glassblowers were producing a variety of wares in Italy and at centers throughout the Roman Empire. As skills developed, the shapes and designs of glassware became more elaborate. Two exceptionally fine examples of the glassmaker's art are this jug and pouring flask made in the busy glass factories of Colonia Agrippina (present-day Cologne), a wealthy city and military base on the Empire's Rhine frontier. The shapely jug is decorated with a design in light blue and yellow, formed by threads of molten colored glass laid onto the surface of the vessel after blowing; the intricate serpentine patterns give the name of "snake-thread" to this form of decoration. The flask beside the jug has been blown in the shape of a helmeted head, here lying crest downward. Ridged threads of patterned blue glass form the sides and nosepiece of the helmet and frame the eyes, which are made from coils of colorless glass. On either side of the head is traced the outline of a bird perched on a twig and pecking at red berries.

C. A.D. 200 British Museum, London

86

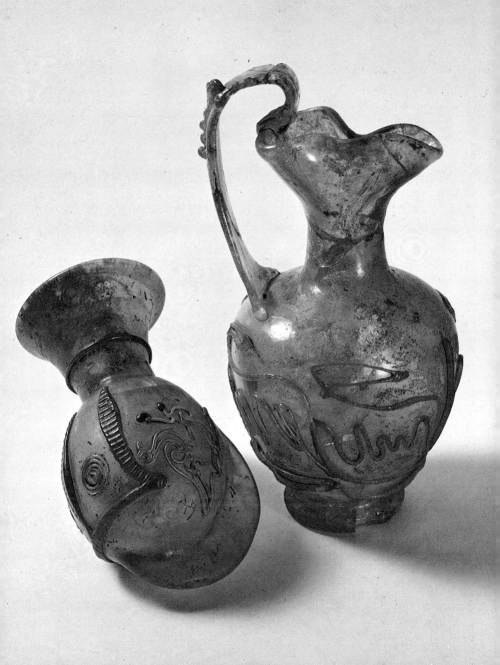

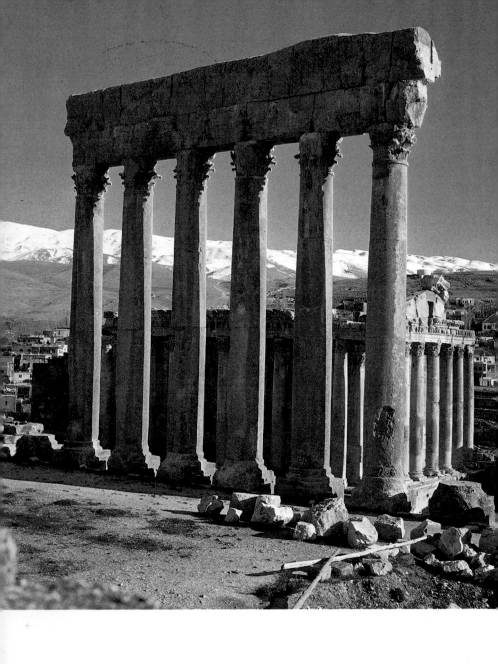

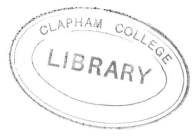
Two Temples at Baalbek

THE ROMANS PLANTED a massive complex of temples at Baalbek in Lebanon, where, in a manner characteristic of the Roman provinces, traditional local deities continued to be worshipped alongside the established Roman pantheon. In the foreground, towering against the snow-capped Lebanese mountains, are the six remaining columns of the massive Temple of Jupiter that dominated the sanctuary. The temple was begun in the first century A.D., soon after the foundation of the Roman colony of Heliopolis, built astride important trade routes from Arabia and the East. The structure, 259 feet long and 158 feet wide, was erected on the site of an earlier, pre-Roman sanctuary of the god Baal, whose pre-eminence among eastern deities led to his association with the supreme Roman god Jupiter.

Beyond the columns of the Temple of Jupiter can be seen those of the later and better preserved Temple of Bacchus—dedicated to the god of regeneration and rebirth, known to the Greeks as Dionysus, whose worship became increasingly popular in Roman times and was also associated with local fertility gods. This temple, like its neighbor, was raised on a high podium, or base. Its Corinthian columns form a colonnade surrounding the central *cella* or shrine, which contained a cult image of the god. Unlike the more austere temples of Greek times, the ceiling of the portico and the interior walls of the *cella* of the Temple of Bacchus were adorned with elaborate carvings. The temple was converted into a Christian church in the fourth century A.D. The entire temple complex at Baalbek, built over a period of 250 years, also contained a colonnaded forecourt some three hundred feet square, several other shrines, and a circular Temple of Venus with a domed roof.

First to third centuries A.D.

89

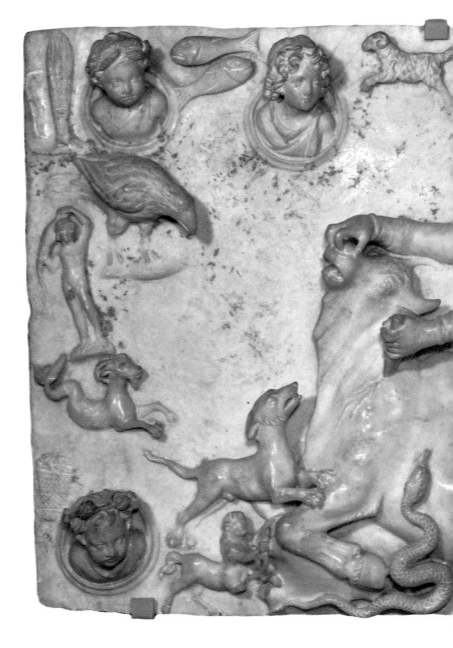

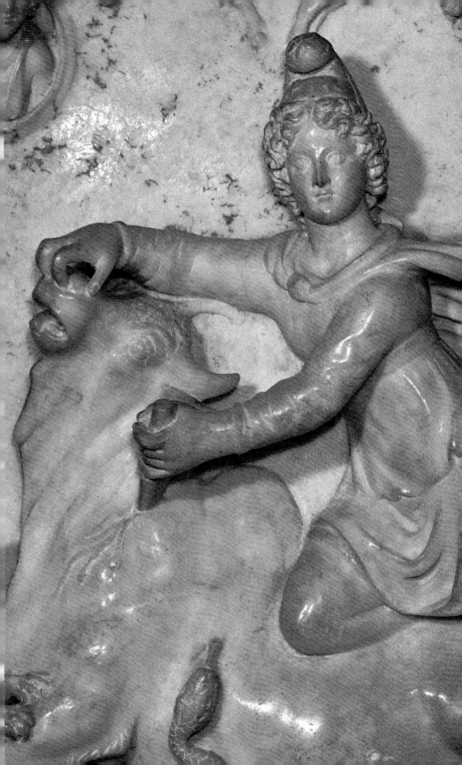

Mithras, Persian God of Light

As their empire expanded, the Romans encountered peoples with widely different religions from their own, and returning soldiers and traders introduced the worship of many foreign gods into Rome. Prominent among the imported cults were the so-called "mystery religions" from the eastern provinces, which bound their converts by elaborate and secret ceremonies into a close-knit community of believers. By far the most important of these new religions was the cult of Mithras, the Persian god of light and wisdom. This marble relief from Sidon, on the Phoenician coast, is typical of numerous representations of Mithras, showing him as a handsome youth with ringlets of hair, wearing a tall Phrygian cap, a flowing cloak, and a long-sleeved tunic, and plunging his knife into the shoulder of a sacrificial bull. A dog and snake, symbols of good, drink the bull's life-giving blood; a scorpion, symbol of evil, attacks its vital organs. Around the scene are displayed the signs of the zodiac.

Mithraism viewed the state of the world as a constant struggle between light and darkness, good and evil. Converts had to undergo rituals involving extremes of heat and cold before being admitted to membership in the cult. Once admitted, the initiate became a partner with Mithras in the struggle for good. The militant character of Mithraism made it especially popular with Roman soldiers, who carried the cult with them to the far corners of the Empire. Indeed, Mithraism might well have become the official religion of the Empire had not Christianity—another new faith of eastern origin—finally proved to have a broader and more enduring appeal.

c. a.d. 200 Louvre Museum, Paris

FOLD OUT HERE

Ulysses and the Sirens

SOME OF THE FINEST MOSAICS in the Roman world are those that were laid on the floors of the homes of wealthy Romans in the townships of North Africa. Classical legends were popular themes for mosaics. This one, from Dougga in Tunisia, shows Ulysses sailing past the island of the Sirens.

Ulysses—called Odysseus by the Greeks—earned a reputation as one of the wiliest of the Greek heroes in the Trojan War. He was said to have devised the stratagem of the wooden horse as a means of infiltrating Greek forces through the heavily defended gates of the besieged city of Troy. Ulysses' cunning stood him in good stead during the many hazards he encountered on his way home to Ithaca after the war, narrated in Homer's *Odyssey*. Among these dangers were the Sirens, sea nymphs whose beguiling songs lured mariners to their destruction. Approaching their island, Ulysses stopped the ears of his crewmen with wax to prevent them from hearing the Sirens' songs. Instead of sealing his own ears, Ulysses had himself lashed to the mast of his ship so that he could hear the Sirens without succumbing to their blandishments.

In such work as this panel the art of the mosaic reached its peak. The subtle variations in the shading of the tiny cube-shaped *tesserae* have enabled the mosaicist to render the features of Ulysses and his companions, and the detail of their shields and the sails of their ship, with a naturalism that a painter could hardly surpass.

Third century A.D. Bardo Museum, Tunis

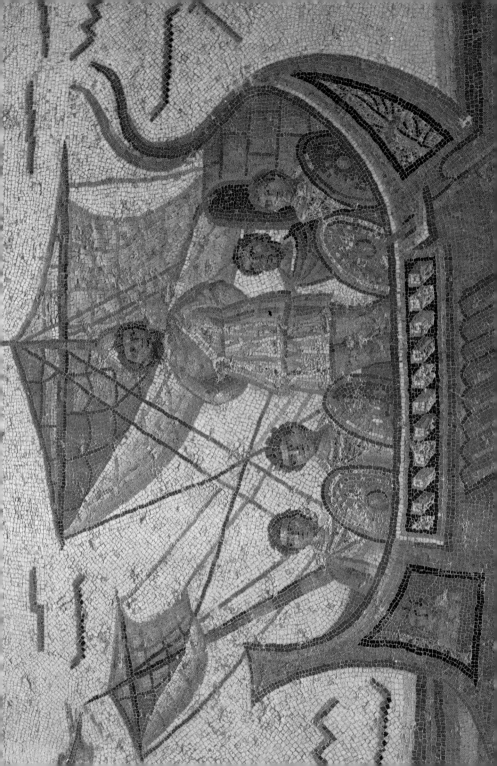

Negro Slave

THE ROMAN ECONOMY depended on the cheap labor of slaves, and throughout the Roman world huge numbers of conquered peoples were forced into slavery. Many were brought back to Rome itself and sold to help pay for the wars that had enslaved them; at the height of the Empire, nearly a third of the population of Rome were slaves. The slave realistically shown cleaning a boot in this bronze statuette is clearly far from his homeland in black Africa. Other slaves were brought as captives of war from Gaul, Britain, or Asia Minor.

The slave became the property of his owner, with no rights of his own. Every Roman household had at least two or three slaves; a rich nobleman might have five hundred, and the emperor's household as many as twenty thousand. Not all the household slaves were restricted to menial jobs such as boot-cleaning. A better educated slave had the chance to become a highly valued cook, craftsman, secretary to a businessman, or steward on a landowner's country estate. Greek slaves were frequently in demand as children's tutors. Some slaves became personal friends of their masters, who treated them well, and many slaves were eventually manumitted or given the status of freedmen which enabled them to set up as shopkeepers or small businessmen on their own.

The lot of the industrial slave was harder. Gangs of thousands of slaves toiled to build bridges, monuments, and aqueducts, or to mine silver, copper, and tin. They were seldom freed, but worked until they dropped from exhaustion. Other slaves were forced to become gladiators, doomed to die in unequal contests in amphitheater spectacles. It was a gladiator slave called Spartacus who in 73 B.C. led a huge slave revolt in Italy; the revolt was ferociously crushed three years later, and six thousand slaves were crucified along the Appian Way.

First to third century A.D. British Museum, London

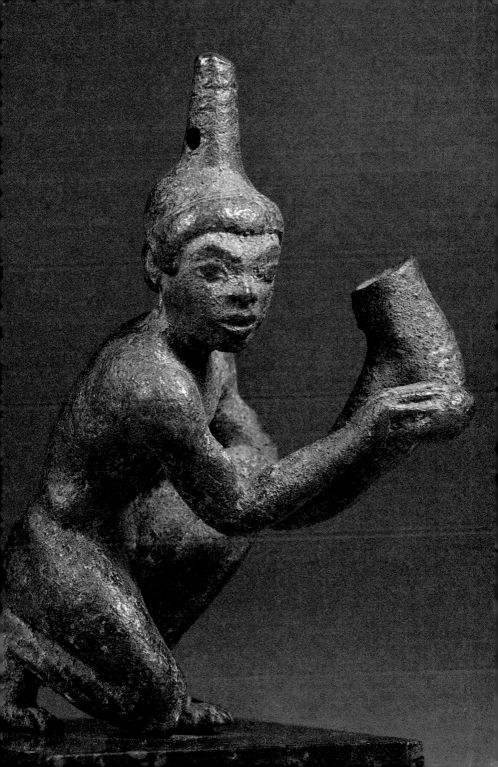

Grape Harvest

A MOSAIC WITH ALL THE COLOR and fine detail of a painting is this scene of the grape harvest on the vaulted roof of the Church of Santa Costanza in Rome. Vine shoots and leaves interlace in an intricate scroll pattern, birds perch on the shoots, and naked boys use hooked sticks to pull down bunches of grapes. Below, two vineyard workers coax their reluctant oxen to pull their laden carts into the farm buildings, while other workers trample the grapes to press out the juice. The scene is one that the skilled mosaicist could easily have observed on the hillsides around Rome and the countryside of Campania to the south, where much of the wine that was freely consumed by Rome's citizens was produced.

The church in which this very secular scene appears was originally a mausoleum built to house the remains of either Constantine, Rome's first Christian emperor, who died in A.D. 337, or his daughter Constantina, who died in 354. The mosaic appears above an ambulatory, or arcaded walk, around the interior of the building.

Constantine's reign gave Christians full freedom of worship, but this portrayal of the wine harvest would still have carried for Romans strong reminders of their recent pagan past; for the vine was sacred to the wine-god Bacchus (the Greek Dionysus), who had long been worshipped by his adherents through a variety of ceremonies ranging from the orgiastic to the mystic.

Mid-fourth century A.D.

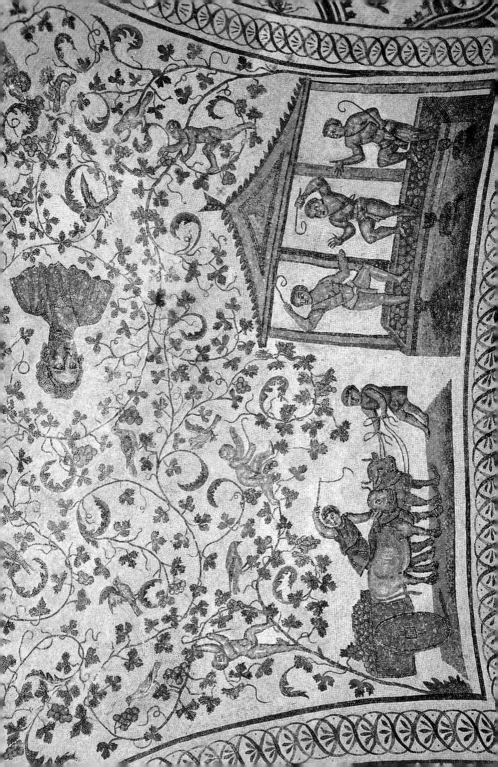

Basilica Nova of Rome

ONLY THE NORTH AISLE now survives of one of the most imposing buildings erected in Rome during imperial times. Called the Basilica Nova, it was the last in a series of great basilicas erected beside the Forum to serve as sheltered halls for commercial and legal dealings. It was begun by the Emperor Maxentius, who ruled from A.D. 306 to 312, and completed by his successor Constantine sometime after 313.

The arches and vaults of the Basilica Nova are constructed of concrete faced with brick. Above the three bays of the side aisle rise huge barrel vaults, their ceilings broken up by sunken recesses, or coffers. This aisle, and a matching aisle on the south side of the building, helped support the massive weight of the basilica's central nave, which towered 115 feet above the ground and ran 260 feet from end to end. At one end of the nave was a semicircular recess designed to hold a huge statue of Constantine. The splendor of the basilica's interior was enhanced by a veneer of glowing marble on the walls and floor, while on the roof of the building bronze tiles sparkled in the Roman sunshine.

Constantine is remembered as the first emperor of Rome to be converted to Christianity. He became sole emperor in the West after a military victory over the usurper Maxentius in A.D. 312, and almost immediately granted Christians freedom of worship, thus ending three centuries of persecution against them. For the first years of his reign Constantine continued the program of building work in Rome that his predecessors had begun. In 324, however, he founded a new capital at Byzantium on the Bosporus. The new city, called Constantinople after the emperor, became the center of a Christian civilization that was to survive the fall of Rome and endure for another thousand years.

A.D. 306–313

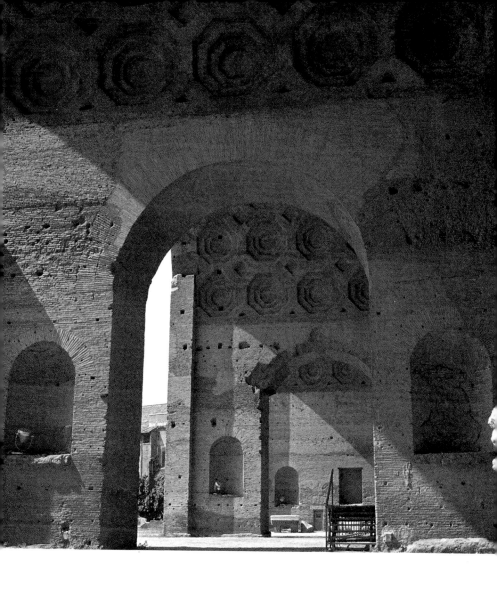

Tomb of a Christian

By THE END OF THE FOURTH CENTURY A.D., Christianity had triumphed over centuries of persecution to become the official religion of the Roman Empire. Temples dedicated to pagan gods were abandoned or adapted to the requirements of the new faith, and a host of new Christian churches were built. The mosaic as a form of decoration was enthusiastically adopted by craftsmen working for Christian patrons, and the floors of the new places of worship were as liberally adorned with mosaics as the villas of well-to-do Roman citizens had ever been. This mosaic from the floor of a church in Carthage covered the tomb of a convert to the new faith. It shows the deceased wearing a brightly decorated tunic and holding up his left hand in a gesture of prayer. Beside him is the familiar *chi-ro* symbol: a monogram, formed from the first two letters of Christ's name in Greek, by which the faithful identified themselves to each other during the years of persecution.

Carthage, a particularly strong center of Christianity in North Africa, was the birthplace of two noted fathers of the early church. Tertullian (A.D. 160–230) was the son of a Roman soldier who was converted to Christianity and became a powerful thinker and prolific writer for the Christian cause. St. Cyprian, a convert as well, became Bishop of Carthage in A.D. 248 and was beheaded ten years later; three of Carthage's churches were later dedicated to him.

Fifth or sixth century A.D. Bardo Museum, Tunis

Pagan Mother Goddess

A HUMBLER CRAFTSMAN than the sculptor in marble, but one capable of remarkably fresh and delicate workmanship, was the maker of small figures in terra cotta. This graceful statuette, about ten inches high, represents a pagan mother goddess seated on a throne. It comes from Attica, the area around Athens that was a noted center of terra cotta craftsmanship from before the Roman conquest to late Roman times. Many of the figurines produced in Attica appear to have been intended as votive offerings to be placed in the sanctuary of a particular god or goddess.

Terra cotta means, literally, "cooked earth," for the terra cotta craftsman's raw material was the same clay that the potter used. After modeling his statuette in clay, the craftsman usually produced from it a two-piece mold, from which numerous copies could be made. Each figurine, when molded, was fired in an oven to harden it, exactly like an earthenware vessel. The figurines were traditionally decorated in bright colors, and this figure still bears traces of the original paint: the goddess's throne is painted red, her drapery blue, and her flesh pink. The statuette also bears the signature of its maker, Leonteus. The manner in which the goddess holds her infant cradled in her left arm was a convention of Roman art that was followed in the paintings of Christian Byzantium. It is not too fanciful, therefore, to see in this effigy of a pagan mother goddess a forerunner of countless portrayals of the Virgin Mary holding the infant Jesus.

A.D. 300 British Museum, London

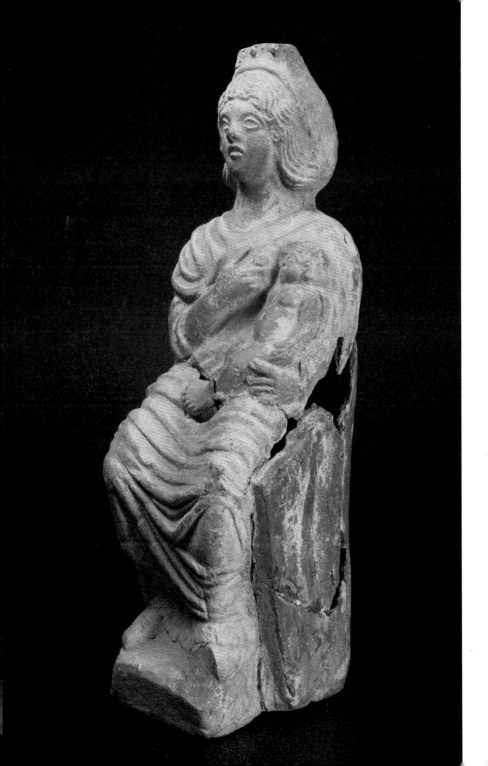

Vandal and His Horse

SWARTHY OF COUNTENANCE and seated confidently on his huge horse, the single Vandal depicted on a mosaic from Carthage aptly personifies the might of the northern barbarians who finally humbled the proud Roman Empire. Aggressive warriors and skilled horsemen, the Germanic tribes of central and northern Europe—Vandals, Goths, Visigoths, Ostrogoths, Alani, and many others—had harried Rome's long European frontiers since the earliest days of the Empire. They were hungry for new lands in the west on which to settle their expanding populations; and they were under pressure in their turn from other nomadic tribesmen moving westward behind them. Emperor after emperor of Rome had to strengthen the Empire's frontier defenses and mount costly campaigns against the restless barbarians beyond them. Some of the more forceful tribes were even given lands within the Empire in return for their help in defending its frontiers. By the end of the fourth century A.D. the pressures finally proved irresistible, and the barbarian tide poured into the western half of the Roman Empire. In A.D. 410 the Visigoths sacked the city of Rome itself.

The barbarians' skill in horsemanship enabled them to travel huge distances at top speed, and some of the Germanic tribes covered thousands of miles in their migrations. The Vandals started moving from their homelands on the Baltic coast of modern Germany around 400, sweeping across Gaul and into Spain. From there they crossed the Straits of Gibraltar and wrought havoc in Rome's North African provinces. In 439 the Vandals took Carthage and made it the center of a Vandal kingdom, which lasted for a century before the Byzantine general Belisarius brought North Africa back into the Roman fold.

A.D. 500 British Museum, London

106

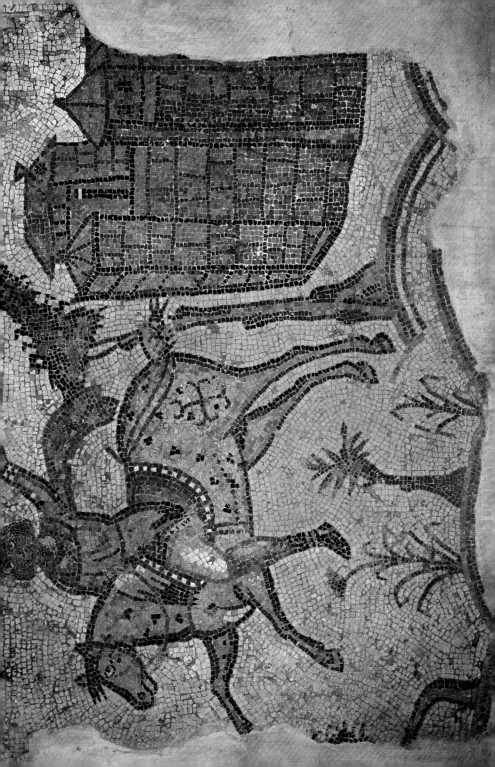

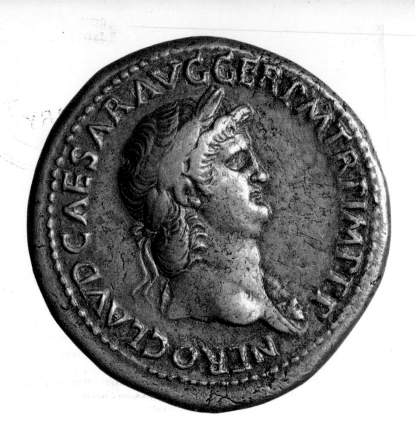

FROM REPUBLIC TO EMPIRE:
FOUR STAGES IN ROME'S EXPANSION

FROM NORTHERN BRITAIN TO THE NILE, from the Atlantic coast of Spain
to the distant Tigris and Euphrates rivers, the Roman Empire at its
height bestrode most of Europe, a wide strip of the North African
coast, and extensive lands in Western Asia. The Emperor Trajan was,
before his death, ruler of some two million square miles of the earth's
surface. Much of this huge empire had been won in the later days of
the Republic, after the brilliant campaigns of such generals as
Pompey the Great and Julius Caesar. Augustus, the first emperor, an-
nexed Egypt and created a defensible European frontier along the
Rhine and the Danube. Later emperors concentrated on holding this
frontier against repeated attacks from outside. Territories won by
Trajan in the east, between the valleys of the Tigris and Euphrates,
were handed back by his successor Hadrian to local rulers.

108

FOLD OUT HERE